WORLD FILM LOCATIONS MADRID

Edited by Lorenzo J. Torres Hortelano

First Published in the UK in 2011 by Intellect Books, The Mill, Parnall Road, Fishponds, Bristol, BS16 3JG, UK

First Published in the USA in 2011 by Intellect Books, The University of Chicago Press, 1427 E. 60th Street, Chicago, IL 60637, USA

Copyright ©2011 Intellect Ltd

Cover photo: Focus Features / The Kobal Collection

Structural Copy Editor: Heather Owen

Intern Support: Joseph Smith

All rights reserved. No part of this publication may be reproduced, stored in a retrieval system, or transmitted, in any form or by any means, electronic, mechanical, photocopying, recording, or otherwise, without written consent

A Catalogue record for this book is available from the British Library

World Film Locations Series
ISSN: 2045-9009
eISSN: 2045-9017

World Film Locations Madrid
ISBN: 978-1-84150-568-8
eISBN: 978-1-84150-593-0

Printed and bound by Bell & Bain Limited, Glasgow

WORLD FILM LOCATIONS
MADRID

EDITOR
Lorenzo J Torres Hortelano

SERIES EDITOR & DESIGN
Gabriel Solomons

CONTRIBUTORS
Antonio Baraybar Fernandez
José Luis Castro de Paz
José Ramón Garitaonaindia de Vera
Rafael Gomez Alonso
Steven Marsh
Agustin Rubio Alcover
John D Sanderson
Helio San Miguel
Lorenzo J Torres Hortelano

LOCATION PHOTOGRAPHY
Alicia G. Gonzalez
Eduardo Hernandez
Miriam Montero
Lara Pérez
Lorenzo J Torres Hortelano

LOCATION MAPS
Joel Keightley

PUBLISHED BY
Intellect
The Mill, Parnall Road,
Fishponds, Bristol, BS16 3JG, UK
T: +44 (0) 117 9589910
F: +44 (0) 117 9589911
E: info@intellectbooks.com

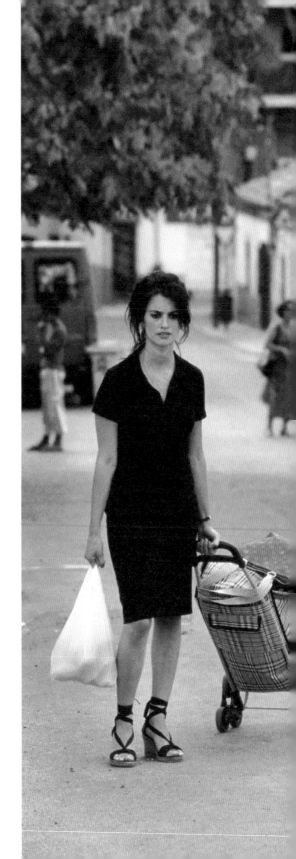

CONTENTS

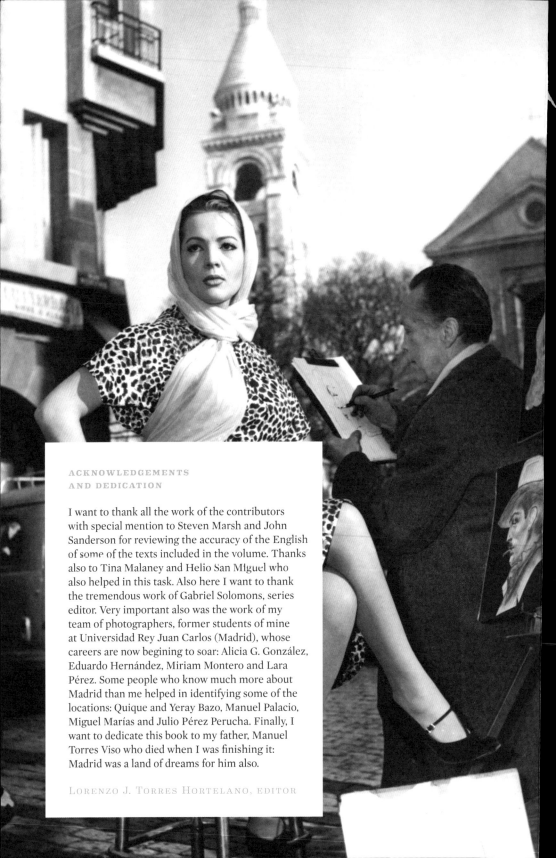

ACKNOWLEDGEMENTS
AND DEDICATION

I want to thank all the work of the contributors
with special mention to Steven Marsh and John
Sanderson for reviewing the accuracy of the English
of some of the texts included in the volume. Thanks
also to Tina Malaney and Helio San Miguel who
also helped in this task. Also here I want to thank
the tremendous work of Gabriel Solomons, series
editor. Very important also was the work of my
team of photographers, former students of mine
at Universidad Rey Juan Carlos (Madrid), whose
careers are now begining to soar: Alicia G. González,
Eduardo Hernández, Miriam Montero and Lara
Pérez. Some people who know much more about
Madrid than me helped in identifying some of the
locations: Quique and Yeray Bazo, Manuel Palacio,
Miguel Marías and Julio Pérez Perucha. Finally, I
want to dedicate this book to my father, Manuel
Torres Viso who died when I was finishing it:
Madrid was a land of dreams for him also.

LORENZO J. TORRES HORTELANO, EDITOR

INTRODUCTION

World Film Locations Madrid

WHEN A BOOK ON CINEMA is launched, the first thing one might try to do is figure out exactly what type of book it is. The book may be aimed at cinephiles, academic scholars or even those who just love to talk about movies. The *World Film Locations* Series does not fit comfortably into any of these categories. What readers will find are the myths and the facts that explain what cinema is today through the representation of the city. We can see what remains today from the early twentieth up to the twenty-first century, and also what cinema has become. Movies are one of the most powerful cultural means of expression and catalyst for society. This series focuses on the representation of an area that was born alongside cinema: the city. In the case of this volume we will focus on Madrid, the capital of Spain. Many believe that Madrid is a very special city, with passionate and intellectual people beyond the ordinary. Here we will show this through some of the best movies that have used Madrid as one of its main characters.

Madrid is arguably Spain's most cinematographic city. Indeed, one of the essays by Helio San Miguel is devoted to this subject. For political and ideological reasons, stemming from the different nationalities that make up the Spanish state, this subject has never been weighted enough; so, an indirect objective of this compilation is to show how Madrid is also the film capital of the Hispanic world. This reinforces, as John D Sanderson shows, why a series of Anglo-Saxon directors have focused on Madrid as a setting for some of the most exciting thrillers of the early twenty-first century, going beyond the Madrid cliché of bulls and football, and demonstrating the modernity of Madrid. We could almost use the term post-modern, if we consider that Spain was the first country in the world to approve homosexual marriage.

This has, surely, as discussed in San Miguel's second essay, influenced the existence of a number of gay-themed films since *La Transición*. But we cannot forget the most popular and traditional Madrid, whose architectural forms still survive in the corralas, verbenas, etc, as analysed here by José Luis Castro de Paz and José Ramón Garitaonaindía de Vera.

At the other extreme, of both the popular and the modern, we find a link to existentialist philosophy, which is manifested in a number of films that Rafael Gómez Alonso discuses. In the same vein we have Steven Marsh's essay, which proposes a counter model of Madrid's underground cinema.

The main body of the book comprises 44 discussions of film scenes from the first productions in Madrid to those of the present day. The criterion for the selection of films is not so much the length of footage that is dedicated to the city (in the case of *Criacuervos/Raise Ravens/Cría!*, Carlos Saura, 1976, only a few short minutes), but the importance of the scenarios, buildings or monuments in the narrative of the film, as well as the intrinsic role of the city of Madrid to the film as a whole.

What makes Madrid great is not just to be found in these essays; it is the culture and social cohesion that makes it a fascinating city: traditional and modern, constantly changing, friendly, intercultural and *castiza* at the same time. It is, then, culture in all its manifestations – and film as a privileged example – that is really important. The images of Madrid as a lively city, popular and cultural, await to fascinate the reader. ✣

Lorenzo J Torres Hortelano, Editor

MADRID

City of the Imagination

Text by
LORENZO
J TORRES
HORTELANO

THERE IS A LONG LIST of directors who have wonderfully represented the city of Madrid. We could have chosen from Juan de Orduña, Saenz de Heredia, Neville, Nieves Conde, Bardem, Fernán-Gómez, Saura, Garci, Colomo, Almodóvar or Amenábar, but it would be wrong to say that any one of them is the director of Madrid. However, another reason is because Madrid, as a city of the imagination, does not really belong to any one person but, rather, it belongs to all. This includes those directors who pass through the city at some stage of their lives and those who remain there. Wherever they come from, Madrid will always be their second home (as also happens to the characters in *Surcos/Furrows*, Nieves Conde, 1951). Furthermore, Madrid, for those who come for the first time, often leads to an epiphany – like the one the main character experiences in *Noviembre/November* (Achero Mañas, 2003).

This awakening to a world of imagination is not just something that happens to characters who populate the films made in

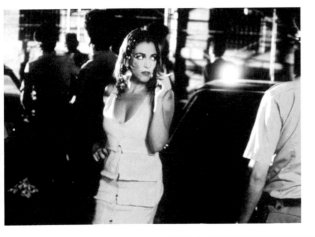

and about Madrid; it is something that can also be seen in certain directors. The most obvious case is Pedro Almodóvar, who was born in a rural environment and did not come to Madrid until he was 22 years old. In his films we can see how the characters blend perfectly with the streets of Madrid – as in the classic scene where Carmen Maura is 'washed' by a municipal employee on the street in *La ley del deseo/Law of Desire* (1987). But, at the same time, it also seems clear that Almodóvar's Madrid, although shot on location, is also partially invented by his imagination. His worldwide success has created a particular yet imaginary depiction of Madrid that international spectators now expect to find and recognize. Some of Madrid's most important Almodovarian elements can indeed be found today, if the visitors know what, and where to look for them, though it is not so much in Almodóvar's settings, with their characters and preference for bright colours, but in the vitality and passion of a city that is gritty and offers the best of itself through its people and culture.

Following Almodóvar's example, we can see a glimpse of Madrid as a city of imagination, but not as an imaginary city. Carlos Saura once said: 'Madrid desde el punto de vista estético y visual, no es ninguna maravilla' ('Madrid from the visual and aesthetic point-of-view, is not that special'). It is not as tidy as Barcelona or as beautiful as Seville, Paris or Rome, nor as evocative as New York or London, but Madrid has something that, in a sense, makes it stand out from all these cities. Nowhere else in the world can visitors feel at home, yet be continuously surprised, as the city is constantly reinvented at every turn. This sheer vitality and reinvention is reflected in the films in which Madrid is the protagonist.

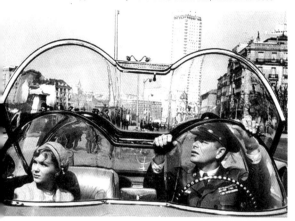

But Madrid can also be rough, messy and dirty, and have chaotic traffic. Even as early as 1929, Nemesio Sobrevila depicted it as such in *El sexto sentido/The Sixth Sense*. Which reminds us that, without showing the extreme griminess so akin to postmodern aesthetics, Madrid has never in history been beautifully imaginary. But let us not have a distorted view of Madrid. It is also a relatively safe city compared to other major capitals. According to *Monocle* magazine, in its 2010 index, Madrid is the tenth most liveable-in city in the world and that same year it also ranked among the twelve greenest European cities. Maybe that is one of the reasons why Madrid is the Spanish city that, more than any other, has welcomed immigration throughout its history.

But then, where does Madrid's true film identity lie? It can lie in its monumental grandeur. Madrid's architectural heritage comes from the eighteenth and nineteenth centuries. Later, in the early 1920s, its rulers came up with the idea of giving Madrid a cosmopolitan Presence, creating what became one of the main imaginary scenarios of the city: the Gran Vía. As with many other public works in Madrid, it took several decades to complete and,

Nowhere else in the world can visitors feel at home, yet be continuously surprised as the city of Madrid is constantly reinvented at every turn.

therefore, it lacks a homogeneous appearance. But it is still one of the most sumptuous and iconic arteries of the city, where imaginary worlds are consumed in abundance, is the home of the largest theatres in the city as well as all the biggest book and music stores.

Perhaps what makes Madrid so special is its world-class cultural offerings: for instance the unique 'Eje del Prado' ('Prado's Mile') with its wonderful collection of museums (Museo del Prado, Museo Nacional de Arte Reina Sofía, Museo Thyssen-Bornemisza, etc). This would have surprised Rita Hayworth in *The Happy Thieves* (Georges Marshall, 1961), when, with Rex Harrison, she has to steal a Goya.

Or maybe it lies in the verbenas and corralas of a more provincial Madrid of yesteryear; in the recent edgy manifestations like La Movida; or in the current cosmopolitan and hectic bars, sidewalk cafés and endless nightlife.

But probably where Madrid offers some of its best performances in regard to film is beyond all those places. It is actually found in the lives of its anonymous citizens, in its neighbourhoods and streets, where life boils and changes constantly and continuously. This is the aspect of Madrid that beckons film producers, directors, and screenwriters from around the world and compels them to tell stories that can appeal to everyone. One of the many examples is the beginning of *La buena estrella/Lucky Star* (Ricardo Franco, 1999), which takes place in an inhospitable area on the outskirts of the city.

The representation of Madrid in cinema is a continuous surprise, full of life in its purest form, unadorned and unsweetened. Thus, the best films are those in which Madrid is not just shown as a tourist location but a city in touch with its deepest cultural roots; in popular events such as the open-air verbenas with their Carnival feel; in artists like Goya and Velázquez, both recognized as masters of light and shadow, but are truly, above all, masters of human psychology. The best cinema of Madrid, as in their canvases and the urban landscape, delineates the life and struggles of the characters. In short, Madrid in cinema is a landscape, a set, but one where its characters are alive and, so, make it come alive. ✤

MADRID

Casa De Campo

② ⑦

④ ①

⑤ Central Madrid

③

⑥ ⑧

LOCATIONS
SCENES 1-8

THE ASSASSINATION AND BURIAL OF DON JOSÉ DE CANALEJAS/ ASESINATO Y ENTIERRO DE DON JOSÉ DE CANALEJAS (1912)

LOCATION *Puerta del Sol, 6 (at Carretas corner) and Spanish Parlamient (Carrera de San Jerónimo)*

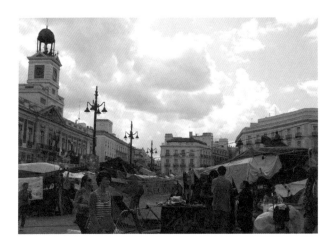

DON JOSÉ DE CANALEJAS (1854-1912) was a lawyer and politician, progressive, regenerationist and liberal, who became President of the Council of Ministers of the Spanish Government. Among his most notable achievements was the abolition of the death penalty and the development of a broad democratic agenda. This silent semi-documentary short-film about Don José de Canalejas' assassination and subsequent funeral is divided into two parts: the first is a fictional recreation of the murder (perpetrated by the anarchist terrorist Manuel Pardiñas) at the actual scene of the crime, just in front of the San Martín bookstore – which closed down in 1995. The second is edited with documentary images of the funeral in Madrid – mostly from Puerta del Sol and the main entrance to the Spanish Parliament. It is packed with people showing their respects to the assassinated President. These two parts, edited without interruption, present two interesting features: firstly, the shop window with the bullet holes acts as a link to both segments; as a location in the fictionalized one and later as documentary footage, when the shop assistant shows the actual effects of the shooting; secondly, since this was a high level political assassination, stressing the murderer's markedly friendly gesture of tapping Mr Canalejas' shoulder seemed to fuel multiple conspiracy theories. Regarding the film's *mise-en-scene*, if we keep in mind that a decade earlier, Edwin S. Porter had used the close-up with dramatic intention, in this film *The Great Train Robbery* (1905), the editing would seem to demand a close-up of the murderer's treacherous gesture, or perhaps an insert of the trigger being pulled. But the directors, maintained a long shot, focusing our interest on Mr. José de Canalejas and in the Madrilean space around him –and not on the killer. **↝Lorenzo J Torres Hortelano**

(Photos © Alicia G. González)

Directed by Enrique Blanco and Adelardo Fernández Arias
Scene description: Murder in front of San Martín Bookstore
Timecode for scene: 1:13:27 – 1:15:52

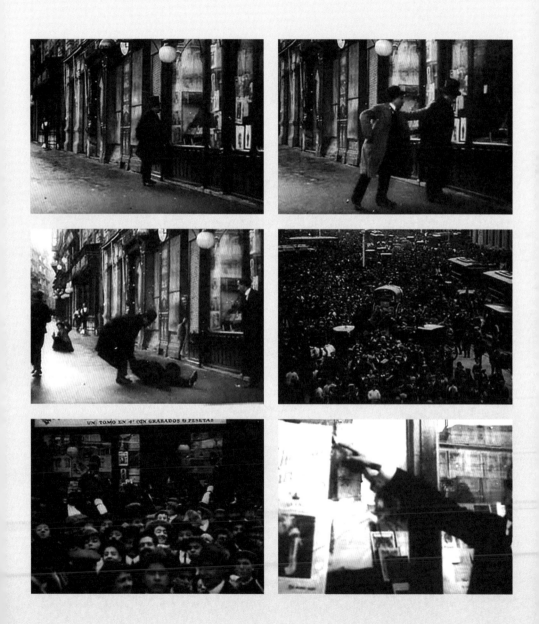

THE SIXTH SENSE/EL SEXTO SENTIDO (1929)

Around Cibeles and Callao

CARLOS AND LEÓN have opposing views of the world. While Carlos is optimistic, León is pessimistic. One day Carlos sends his friend to see Kamus, the inventor of the 'sixth sense', a machine much like a film camera that has the capacity to capture the *objective truth*. 'Este es el verdadero Madrid visto sin ninguna deformación literaria' ('This is the true Madrid, seen without any literary deformations') Kamus tells him. 'Este aparato nos da la sensación del verano mejor que cualquier literato' ('This device gives us the feeling of summer better than any writer'). Different views of Madrid's landmarks appear on screen, intermixed with street scenes. Among them there is one scene in which Carmen, Carlos' girlfriend, gives money to another man. Confronted with this seemingly-unquestionable evidence, León interprets the images according to the social conventions he believes in. He tells Carmen that Carlos does not want to see her anymore and later he informs Carlos and lets him know that Kamus has the proof. Carlos visits Kamus and immediately recognizes the man in the filmstrip as Carmen's father. The misunderstanding does not come from the images but from the different interpretations that can be construed based on the information and values one holds. *El sexto sentido* is a somehow naïve, clumsy and simplistic silent film, but at the same time it displayed a clever critique of Dziga Vertov's acclaimed *Film Truth (Kino-Pravda)* newsreels. It also moves us to reflect on the relationship between reality and its representation, on the capacity of our tools to objectively reproduce and respond to reality. It also shows the primacy of image over word – an issue even more pressing today when we rely on a growing number of screens for much of our access to information about the world. Simply for this reason, Sobrevilla's film deserved to have a larger echo than it did, but unfortunately it never opened commercially and remains a forgotten little gem. ↠**Helio San Miguel**

(Photos © Eduardo Hernández)

Directed by Nemesio Sobrevilla
Scene description: Kamus shows León images of Madrid
Timecode for scene: 1:13:27 – 1:15:52

Images © 1935 Compañía Industrial Film Español S.A. (CIFESA)

FAIR OF THE DOVE/
LA VERBENA DE LA PALOMA (1935)

Barrio de la Paloma

BASED ON one of the jewels of Spanish zarzuela, whose script could be considered the forerunner of the sainete farce (a popular Spanish comic opera piece) years before the 'grotesque tragedies' of Carlos Arniches. The film version by Benito Perojo hybridized Hollywood narrative with popular cultural musical tradition to become one of the great masterpieces of Spanish cinema. It also exemplifies a developing Republican 'national popular' cinema a year before a military uprising will overshadow any festivity. The characters (Don Hilarión, Casta and Susana, Julián, 'Señá' Rita, chulapas and chulapos – Madrid girls and boys in traditional dress), are more than just stereotypes of the residents of the corralas of Barrio de la Paloma and display a pure but undeniable realism. The film, an extraordinary success in its reconstruction of a brotherhood of 1893, stands out for its exceptional sophistication of sets, costumes and props. It adds new situations to the original script and transforms others, testimony to the progressive interests of a director who always aligned himself with the small concerns and intimate anguish of the workers who star in the story and whose class position in the film is accurately reflected. The night sequence in which Julián seeks Susana in the crowd shows a love affair on the verge of a happy ending against the bustle of carriages and boats, the paper chains that adorn the streets and the stalls selling fritters and donuts.
↝ *José Luis Castro de Paz and José Ramón Garitaonaindía*

(Photos © Eduardo Hernández)

Directed by Benito Perojo
Scene description: The verbena, funfair night action
Timecode for scene: 1:04:29 – 1:07:50

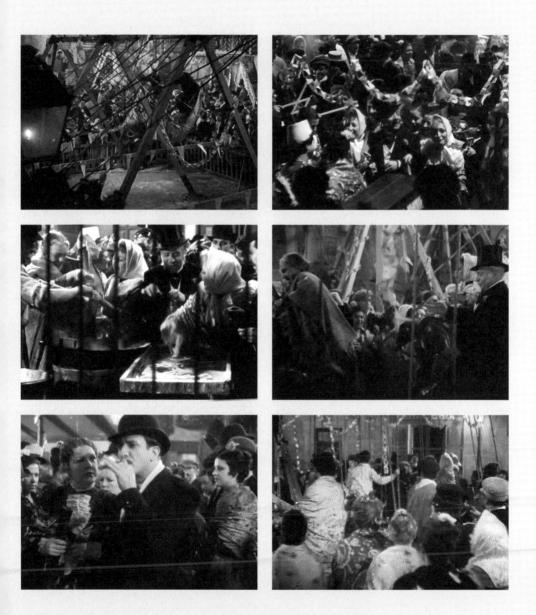

Images © 1943 Espana Films; Judez-Films

TOWER OF THE SEVEN HUNCHBACKS/
LA TORRE DE LOS SIETE JOROBADOS (1923)

LOCATION *Plaza de la Paja and Calle de la Morería*

FOLLOWING HIS ESCAPE from the ancient catacombs and synagogue built deep beneath the historical (Jewish, Arab and Christian) centre of the old city, Basilio Beltrán (Antonio Casal) attempts to lead the police to the subterranean chamber where he and Inés (Isabel de Pomes) have been held. Meanwhile, the film's evil genius, Doctor Sabatini (Guillermo Marín), the chief hunchback and architect of the counterfeiting operation that Basilio has exposed, lays explosives at different points of access to his underground lair which he dramatically blows up. Pillars and beams come crashing down, the impressive spiral staircase collapses before our eyes, and the screen fills with clouds of dust and fallen masonry. The mise-en-scène of this film is clearly and consistently indebted to the early Fritz Lang (*Metropolis*, 1927) and Robert Weine (*The Cabinet of Dr Caligari*, 1920); famous for German Expressionism, but rarely more so than in this sequence. Cinematographically impressive, this scene is a precursor of later disaster films. It provides a unique example of 'the fantastic' within Spanish film history. Generically, it condenses in one scene the formal and aesthetic tension that pulsates throughout the film in its entirety, between the taut hybrid of German expressionism and the locally specific, popular theatrical and musical forms associated with Madrid. In this sense, the implosion of the city, its collapse upon itself, serves as an apt metaphor for the undoing of the discursive artifice that is Madrid. •◆***Steven Marsh***

(Photos © Miriam Montero)

Directed by Edgar Neville
Scene description: Doctor Sabatini blows up the underground city
Timecode for scene: 1:17:13 – 1:17:59

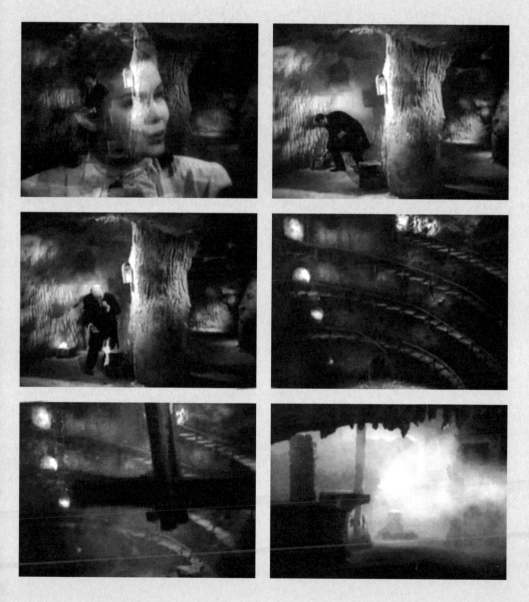

Images © 1943 Espana Films; Judez-Films

SUNDAY CARNIVAL/
DOMINGO DE CARNAVAL (1925)

El Rastro and Plaza de Cascorro

CLEARLY IN THE STYLE of the Spanish playwright Arniches, (famous for his sainetes or comic-theatre plays), and artistically influenced by the paintings of Francisco de Goya and José Gutiérrez Solana, *Domingo de Carnaval* is set in the slums of 1917 Madrid. The carnival was banned by the Franco regime and the film is a celebration of well-planned dissent. Despite the formal crime plot – about the murder of a secondhand dealer in a neighbourhood corrala (a popular residential building of traditional Madrid) – Neville's framing goes beyond traditional narrative function to delight in a display of popular authenticity, in the style, perhaps, of the carnivalesque, theorized by Mikhail Bakhtin. Alongside the crime element there is a love story between the two main characters: the young cop (Fernando Fernán-Gómez) and Nieves (Conchita Montes), who is the daughter of one of the salesmen. The director gives maximum visual relevance to the background, which bustles about behind the main action. This explains the predominance of wide-, long- and medium-long shots that convey the popular bustle of El Rastro, a famous flea market in Madrid, and nearby areas such as Plaza de Cascorro. Neville, forgoes the conventionally 'dramatic', diluting the plot development in order to show life in the crowded streets. His camera even stops at the stand of charlatan, Salvador Báez (a famous market salesmen in the 1940s), and a gypsy woman selling ointment for 'scabs'. **➻José Luis Castro de Paz and José Ramón Garitaonaindía**

(Photos © Miriam Montero)

Directed by Edgar Neville
Scene description: Pedlars in El Rastro
Timecode for scene: 0:53:10 – 0:54:45

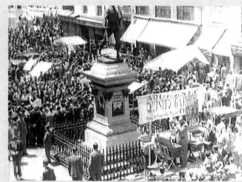

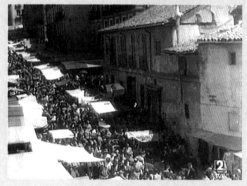

Images © 1945 Edgar Neville; Exclusivas Salet-Jimeno

THEY ALWAYS COME AT DAWN/
SIEMPRE VUELVEN DE MADRUGADA (1948)

LOCATION *Barrio de La Paloma*

FILMED LARGELY ON LOCATION, written by Miguel Mihura and directed by his brother Jerónimo, this little-known and outstanding feature film is set in the dark, dismal and criminal part of Madrid after the Spanish Civil War. Though cut by censorship, it is a successful combination of generic features of Hollywood film noir. This is clear through the great lighting of the director of photography Jules Krugër (*Pépé le Moko*, Julien Duvivier, 1937), the night and urban ambience, the hopeless and sceptical tone of the events of the narration, and has the hidden intention of talking about Spain in 1948. Using the traditional omniscience of the classic starting sequence, the camera crane moves to show the activity on the balconies of the popular neighbourhood and the erratic movement of people during the night verbena (festival), with the big wheel spinning incessantly. Slowly descending, the camera catches the rigid face of the murderer, Andrés, hardened by the lights from the barracks. The disturbing soundtrack (Manuel Parada) – distorted and unrecognizable fragments of popular pieces interspersed with street buzz – reinforces the claustrophobic sense of isolation and loneliness. This eats away at the festive appearance, showing the core of post-war Madrid. The whole film is infected by this disturbing environment, inhabited by young people, unsuccessful ex-students, all damaged by war. All the characters are condemned to a sickening wandering, morally, and above all visually, in a dark and pathetic Madrid. **José Luis Castro de Paz and José Ramón Garitaonaindía**

(Photos © Miriam Montero)

Directed by Jerónimo Mihura
Scene description: The verbena and death in the dark post-war
Timecode for scene: 0:01:48 – 0:03:20

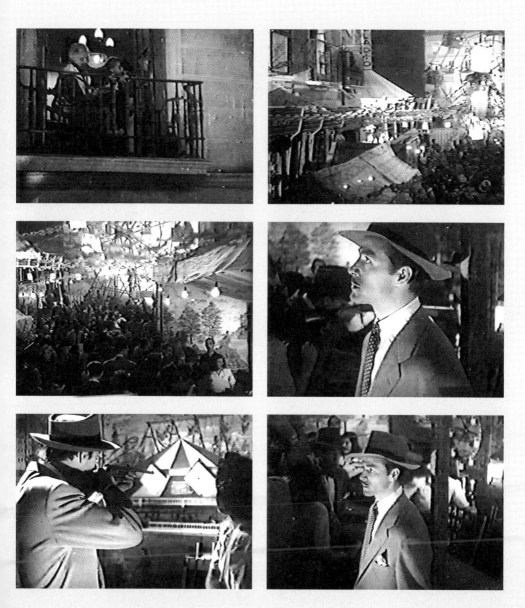

Images © 1948 Peña Films

THE LAST HORSE/EL ÚLTIMO CABALLO (1950)

LOCATION *Gran Vía around Montera looking towards Callao*

IN *EL ÚLTIMO CABALLO*, a charming film that is an ode to preindustrial times, Madrid is seen as a bustling metropolis corrupted by mechanization, where cars are destroying an old Arcadian order in harmony with nature. After drinking non-stop the three main characters (an office worker, a fire-fighter, and a florist) are completely drunk. This sequence starts with a long take lasting over two minutes. It is sustained by the great performances of Fernando Fernán-Gómez, Conchita Montes, and José Luis Ozores delivering a tirade against the modern world. Afterwards, they step out of La Cruzada (The Crusade), the aptly named bar where their faithful horse, Bucéfalo, is waiting for them when they decide to take action. First, they heckle passing motorists and, finally, they take the horse to stop traffic in Gran Vía, one of Madrid's most important and busiest streets. Some drivers are amused, but not the police, who take them into custody. However, no matter how inebriated they were, their rebellious attitude serves as the catalyst for their change. The office worker will quit his job, the fired fire-fighter will realize that he wants to be a peasant, and the three of them will team up with the owner of a plot of land, that is suitable for cultivation. They will grow flowers and will deliver them to the florists' stand in a carriage drawn by Bucéfalo, instead of by car. They might not achieve the lofty goal of changing society or even stop the mechanization of Madrid, but they find peace within themselves and a way to make an honest living according to their principles in the hectic big city. ➙**Helio San Miguel**

(Photos © Eduardo Hernández)

Directed by Edgar Neville

Scene description: *After drinking heavily, three friends take their horse and stop the traffic in Gran Vía*

Timecode for scene: *1:03:40 – 1:07:27*

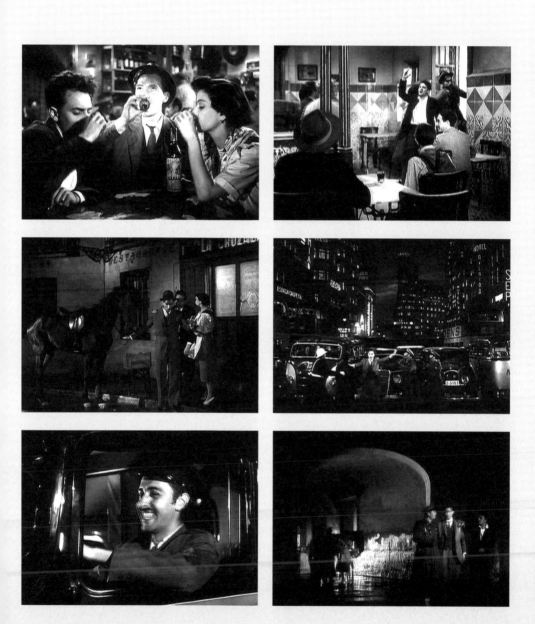

Images © 1950 E. Neville

FURROWS/SURCOS (1951)

Corrala in Barrio de Lavapiés

RELEASED AFTER SERIOUS PROBLEMS with censorship and directed by the pro-Falange-Hedilla José Antonio Nieves Conde (who wrote *Rebeldía* [*Rebelliousness*] in 1954) with script collaboration by writer Gonzalo Torrente Ballester, *Furrows* is a deeply critical film about the situation of Rural migrants who arrived in great numbers in Madrid at the end of the Spanish Civil War. While related to neorealism through some shared traits, its cultural roots extend from Cervantes to Pérez Galdós and Pío Baroja; and from *La aldea maldita/The Cursed Village* (Florián Rey, 1930) to Hollywood film noirs. It was a successful linking of melodrama with traits of the sainete but it lacks a certain humour. It conveys a strong sense of apprehension and anguish, helped by provoking a sense of memory in its audience of the vicissitudes of different groups of characters in a hostile environment, in an occupied country and a city under siege. This is manifested in many ways throughout the film and perhaps one of the most surprising and cruellest motifs is the presence (in the *corrala*, in the gardens) of a marauding horde of hungry children, some of the unsympathetic madrileños. They are capable of rushing, like real monsters, after chickens, cigarettes or sweets at the slightest sign of neglect by their rightful owners. Parallel lines (the furrows in the title), like bars, frequently appear: the best example of which is the repeated presence of the railings of the almost non-existant Madrid home of the Pérez family.

⊷ José Luis Castro de Paz and José Ramón Garitaonaindía

(Photos © Eduardo Hernández)

Directed by José Antonio Nieves Conde
Scene description: The corrala turned into a prison
Timecode for scene: 0:03:56 – 0:05:30

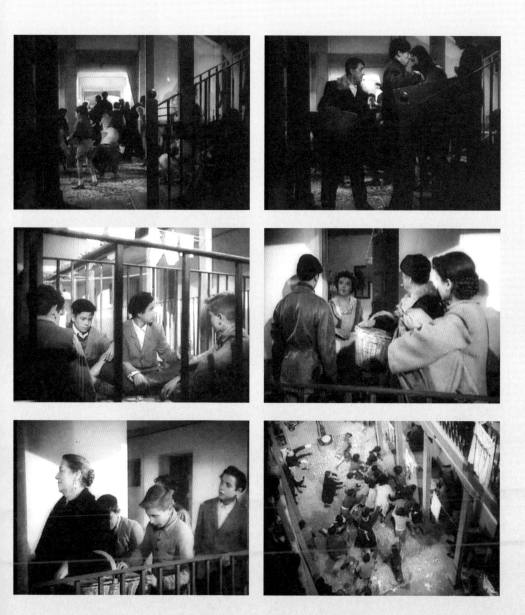

Images © 1951 Atenea Films

MADRID IN MOTION

Squares, Corralas, Markets and Verbenas

Text by
JOSÉ LUIS
CASTRO DE PAZ
AND
JOSÉ RAMÓN
GARITAONAINDÍA
DE VERA

MADE IN MADRID for the popular audiences as one more spectacle, like the eighteenth century *sainetes* by Ramón de la Cruz — liked by Goya, despite criticism from the upper classes, who said they were featured and were intended for the unhappiest mob, 'the disgusting scum of the suburbs of Madrid' —, like the subsequent *weekly serials* (highly successful popular novels with the aim of transforming and educating) and, as with the *sainetes* set in Madrid by Carlos Arniches (containing humour with a strong regional flavour, everyday stories of simple people, like a popular chorus, with a comic transformation of the language) Spanish cinema found its most singular, visual and dramatic characteristic in motifs, shapes and life customs of the humble people who lived in traditional neighbourhoods. Since the twenties, not only were adaptations written, but also original 'themes' were inspired by the typical elements of one-act farces (*El pilluelo de Madrid*, Florián Rey, 1926; ¡*Viva Madrid que es mi pueblo!*, Fernando Delgado, 1928), that conferred on the *corralas* and *verbenas*, the squares and markets of Madrid the maximum spatial and narrative role. We can also find, in the silent period, adaptations of *zarzuelas* (Spanish Operettas), one of them, the famous *La verbena de la Paloma* (libretto by Ricardo de la Vega, music by Tomás Bretón, premiered at the Apollo Theatre with a great success in 1894), of which José Busch did a version in 1921, turning it into film material with iconic and humorous elements of the *verbena* in Madrid (the 'fellows' of course, but also the shawls, the fritters, the *chotis* or the barrel-organ).

With the advent of the Second Republic in 1931 the *corrala* and *verbena* traditionally from Madrid will be one of the main bases of a reliable and effective national-popular cinema. Moderately progressive, and broadly accepted, the influence of some critical and traditional plays written by authors such as Wenceslao Fernández Flórez (*El malvado Carabel*, Edgar Neville, 1935) or the 'grotesque tragedy' (a Spanish satiric genre) by Carlos Arniches (*Es mi hombre*, directed by Benito Perojo in 1934) helped create a popular cinema that was comical and with traditional material typical of Madrid (for example *Don Quintín el amargao/Don Quintín the Bitter*, Luis Marquina, 1935 produced by Luis Buñuel for Filmófono). Thus, the excellent version of *La verbena de la Paloma/Fair of the Dove* shot in 1935 by Perojo himself for CIFESA (Compañía Industrial Film Español, SA) is not only one of the great Spanish film musicals, with careful reconstructions of the traditional Madrid at the end of nineteenth century (Cava Alta, Cava Baja, Don Pedro, Toledo, the outskirts of Plaza de la Cebada, etc.) but, as it was necessary to extend the libretto to match the standard length of a commercial film, it introduced important new sequences. One example is of the chocolate and fritters at 'Señá' Rita bar after the wedding of a couple of workers. During it, entrepreneurs, workers and artisans fraternize, staged quite naturally, and forming the social basis of the Frente Popular (Popular Front) which won the election in February 1936.

After the Civil War — and despite what some historians usually think and often write — the *sainete* set in Madrid was severely criticized by the Franco regime, which did not want to see a single metre of celluloid 'wasted' on the Madrid of

Bordadores Street Crime (1946): a traditional re-creation of a set of images of Madrid in the nineteenth century, from the categories of the tale of manners and traditional characters, representative of a specific national point of view that emerged from the popular classes.

Neville's decisive films, essentially, allow people to understand the crucial aesthetic transformation of the use of popular Madrid in Spanish cinema. Since the fifties, there was a significant process of progressive tension of the eye, similar to that of artists and writers such as Goya and Valle-Inclán, that reached its highest point, in the sixties, with the films of Luis García Berlanga and Fernando Fernán-Gómez (the chaotic *sainete* set in Madrid and in the style of Jardiel Poncela, *La vida por delante/Life Ahead* (1958) or the heart-breaking grotesque melodrama *El mundo sigue/Life Goes On* (1963), set in the Maravillas quarter). The emergence of that grotesque eye that observes Madrid from above and in anger, distorting the faces of characters that were originally purely comic, in order to better show the sad Spanish reality, emerged, quite literally and not by chance, in a crucial festival sequence of the seminal *Esa pareja feliz/That Happy Couple* (Juan Antonio Bardem and LG Berlanga, 1951). There, the two main characters (Carmen/Elvira Quintillá and Juan/Fernando Fernán-Gómez) look into their pasts, from the roof of the building they sublet, from a time and declarative distance as if it were a movie: the beginning of their relationship in a *verbena* in Madrid, where, in turn, the characters, perched on top of a broken big wheel watched hopefully the dark post-war nightfall. It is this subtle and crucial position on the big wheel (the past) and the roof (the present) which metaphorically reflect the vantage point from which Berlanga will build his dark comedies. But also the humus from which Pedro Almodóvar (¿Qué he hecho yo para merecer esto!!/What Have I Done to Deserve This?!, 1984) and Alex de la Iglesia (*El día de la bestia/The Day of the Beast*, 1995) build from and continue filming unforgettable stories: movies about the people of Madrid. ✢

'tacky fellows, leandras and proletarian caps' that had filled Republican screens. However, unique, extraordinary and cultured film-makers such as Edgar Neville or the Republican Manuel Mur Oti faced down the most reactionary sectors of the Regime to continue making films where the festive and popular Madrid of the corralas and antebellum verbenas became, metaphorically, a melancholy song (*Verbena*, Edgar Neville, 1940), a critical cry (*Surcos/Furrows*, 1951; *El inquilino/The Tenant*, 1957) or a clear premonition of tragedy (*Siempre vuelven de madrugada*, Jerónimo Mihura, 1947; *Cielo negro/Black Sky*, Manuel Mur Oti, 1951). Edgar Neville's regenerationist and culturally-dissident mood would reach its highest aesthetic, anthropological point and civic significance with the Madrid 'trilogy' of *La torre de los siete jorobados/Tower of the Seven Hunchbacks* (1944), *Domingo de carnaval/Sunday Carnival* (1945) and *El crimen de la calle de Bordadores/The*

the Spanish cinema found its most singular, visual and dramatic characteristic in motifs, shapes and life customs of the humble people who lived in traditional neighbourhoods.

MADRID

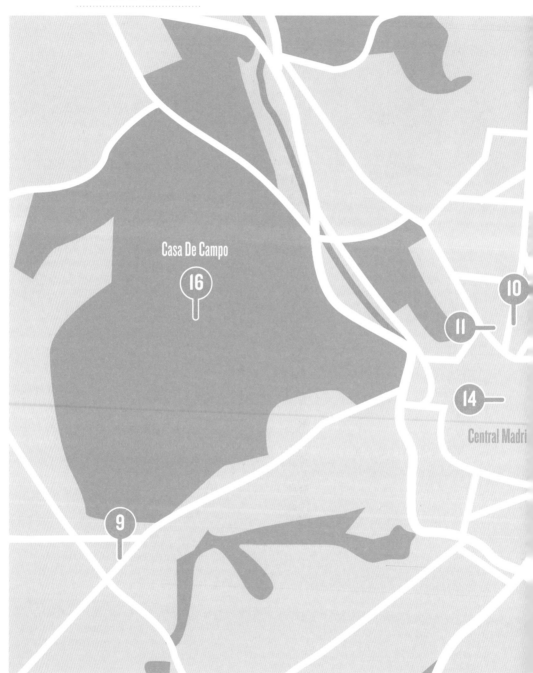

Casa De Campo

16

10

11

14

Central Madri

9

LOCATIONS
SCENES 9-16

DEATH OF A CYCLIST/
MUERTE DE UN CICLISTA (1955)

LOCATION *Carretera and Paseo de Extremadura (close to Madrid)*

IN THIS DENSE and poignant movie, Madrid represents a microcosm that encapsulates the situation of the country at the time. The event that allows us to peek into this urban world is an accident that takes place outside the city. On a grey, rainy and winter day, two lovers run over a cyclist and escape without helping him. At the end of the film they go back to the same spot, but their lives have been dramatically changed. In between these two events lies the Madrid of the 1950s. First we see the portrait of the upper class, the political and financial elite that delivers important speeches, goes to horse races and charity functions; but, as seen through celebrated director Juan Antonio Bardem's eyes, behind that façade of respectability it is rotten to the core. It is in this privileged Madrid that the main character Juan (Alberto Closas) is willingly trapped. However, the consequences of the accident will be the catalyst that unveils his deeply-buried and suppressed feelings which will take him beyond the narrow scope of his social class, out of his comfortable position at the University and into another Madrid. This Madrid is one of student protests, of marginalized neighbourhoods and churches of the underprivileged, like the man Juan killed. These people live a life that he had never considered. His journey is much more than a physical one; it is a personal one. At the end, Juan will try to recover his dignity, redeem himself and pay for his mistakes. To do this he will have to leave Madrid and return to the place where the accident took place. This time the sun is setting and its light could represent a glimmer of hope for a new start. Or perhaps it is a last and fading moment of clarity before darkness. **➵Helio San Miguel**

(Photo © Lorenzo Torres)

Directed by Juan Antonio Bardem
Scene description: A car runs over a cyclist in the outskirts of Madrid
Timecode for scene: 0:00: 55 – 0:04:21

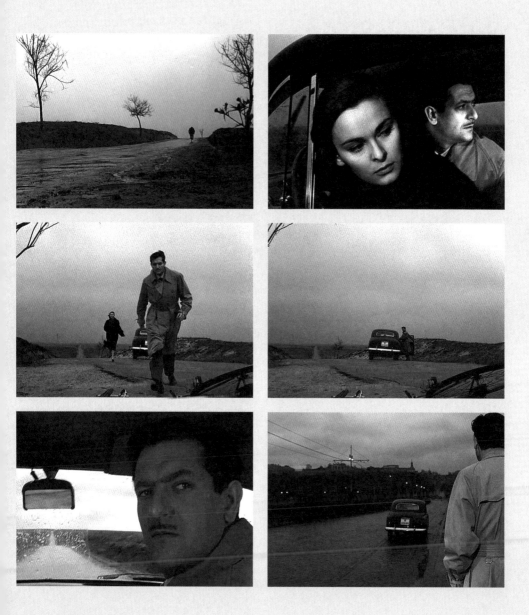

Images © 1955 Guión Producciones Cinematográficas; Suevia Films

THE TENANT/EL INQUILINO (1957)

LOCATION *Calle de la Palma*

THE TENANT SUFFERS the severity of the prohibition established by the Department of Housing of the Franco government. It is hardly surprising that the film upset the authorities from the start because of the premeditated fashion in which it details the high (and increasing) cost of living, with persistent and detailed references to the prices of 'edible stuffs'. Few films better portray the Madrid of the intense transition period during the Franco regime, between autarchy and developmentalism, between extreme poverty and huge fortunes being amassed by a privileged handful at the expense of the rabble. Madrid is covered with for-sale signs for apartments which the main character cannot afford. It is also sprinkled with lavish houses of the powerful few, overlooking the Congress on 'Calle San Jerónimo', while the poor are evicted from the courtyards where they lead, despite everything, a cheerful communal life in their flimsy-walled hovels, until they get kicked out and wind up on the street. So they roam from the illusory tall skyscrapers such as the 'World tower' that clash with the skyline of Madrid, to the modern district 'Mundis jauja' ('World joy') promoted by the real-estate agency, or the oneiric and dystopian districts 'of Happiness' and 'of Hope', or even the shacks of shanty towns and the unpaved streets of the inner city where teams of workmen labour tirelessly and where there are those familiar tacky bars with braid-curtains where 'cazalla' (dry anisette) is consumed. This is the place where local 'cuplé' singers sing the 'chotis' to the sound of a hurdy-gurdy, as well as the site of comic-taurine shows devised for the Monumental de Las Ventas bullring – like the one in which Evaristo (Fernando Fernán-Gómez) plays the mythical role of don Tancredo, using carts to move out to end up in the public square. **•❖Agustín Rubio Alcover**

(Photos © Lara Pérez)

Directed by José Antonio Nieves Conde
Scene description: Ending: moving to the public square
Timecode for scene: 1:33:15 – 1:37:15

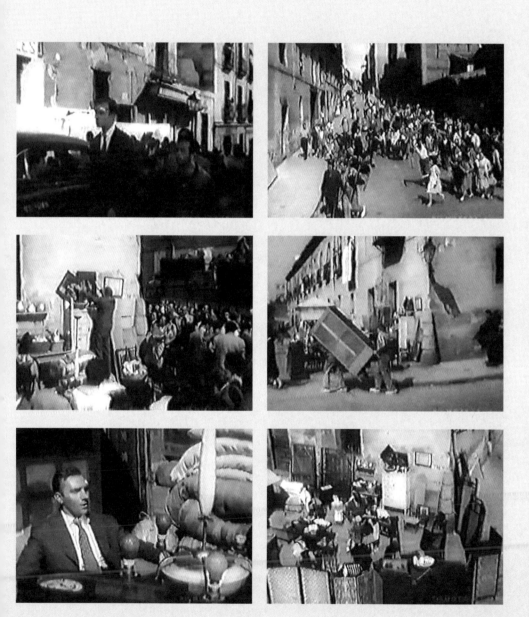

Images © 1957 Films Españoles Cooperativa

THE LITTLE APARTMENT/EL PISITO (1958)

Mostenses, 11 (close to Gran Vía)

THE POST-WAR housing crisis of central Madrid could not have been more searingly depicted than in Italian filmmaker Marco Ferreri's first feature in what would prove to be an illustrious directorial career. Ferreri's febrile and anarchic imagination chimed well with the scatological inventiveness of his screenwriting collaborator, Rafael Azcona. This scene is exemplary of this partnership's mutual interest in the body and its dysfunctions as metaphor for both celebratory practices and social malaise. Indeed, the materialist topography of the body establishes the entire structure of *El pisito*. Petrita (Mary Carrillo) prepares omelette sandwiches at the dining table of the chaotic, overcrowded and diminutive flat she is obliged to share with her sister's extensive brood. Sitting on a chamber pot plonked in the centre of the same table is a grizzling toddler who is being force-fed by his mother, Rosa. Located in a typical housing complex at the heart of Madrid – a cacophonic community of bickering neighbours, warring family members and their various domestic animals. This scene provides a graphic example of what the Soviet cultural theorist Mikhail Bakhtin conceived as the bodily cosmology, one distinguished by an intimate relation between the mouth and the anus, by the regenerative circularity of physical consumption simultaneous with corporeal evacuation. It is a parody of the archetypical banquet scenario but also a telling synecdoche of the repression and dysfunction of the wider Spanish society of the period. The real 'pisito', or even the street of its building does not exist anymore, but the closest configuration would be calle Mostenses, eleven, where you can find nowadays the popular restaurant *Da Nicola*. **Steven Marsh**

(Photo © Miriam Montero)

Directed by Marco Ferreri
Scene description: *A child sits on a chamber pot in the centre of the dining table as his mother plies him with food*
Timecode for scene: *0:15:51 – 0:17:04*

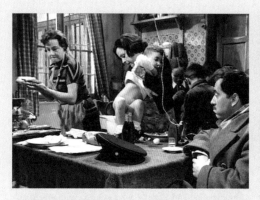 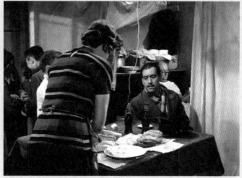

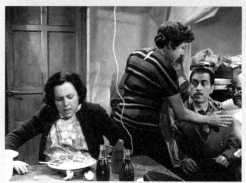

Images © 1958 Documento Films

THE LITTLE COACH/EL COCHECITO (1960)

LOCATION *El Parque de El Retiro*

THE LITTLE COACH (which won the FIPRESCI Prize at the Venice film festival), is a black comedy directed by Italian filmmaker Marco Ferreri and based on a novella written by Rafael Azcona, who also wrote the screenplay (he later became Spain's best scriptwriter writing nearly a hundred movies, including some of the finest films ever made in Spain). *The Little Coach* is one of them. The grotesque story of don Anselmo (José Isbert), an old widower who feels left out because of his lack of disabilities and wants to buy a motorized wheelchair to spend more time with his handicapped friends. The idea is planted in his head when he goes with his friend don Lucas (José Álvarez, 'Lepe') to the cemetery and develops when he travels with all his friends to the outskirts of the city. This idea becomes an obsession when he attends the First World Competition For Motorized People with Physical Disabilities that takes place in El Retiro, the famous park in the centre of Madrid. There, don Anselmo enjoys the convivial atmosphere, gets a taste of the motorized wheelchair and is quickly diagnosed with a dangerous condition in his legs by the same person who wants to sell him one. The freedom of movement which the motorized wheelchair allows, along with open spaces like El Retiro Park, serve as a counterpoint to the oppressive and claustrophobic environment, both physically and emotionally, represented by don Anselmo's family and home. In the fast-developing Spain of the time, the motorized wanderings of don Anselmo and his friends allow us to see a cross-section of Madrid through different neighbourhoods and classes. A city with a chasm between the official Christian values of Franco's regime, and the selfish behaviour of its inhabitants, as well as a sardonic critique of government-promoted modernization and industrial development. ➻ *Helio San Miguel*

(Photos © Miriam Montero)

Directed by Marco Ferreri
Scene description: Race of motorized wheelchairs
Timecode for scene: 0:45:01 – 0:50:47

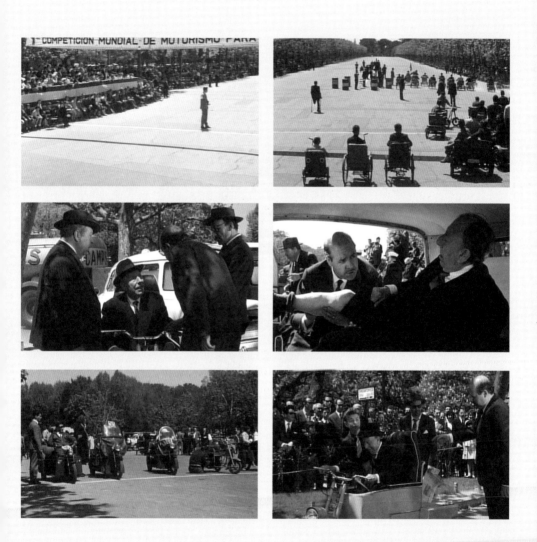

Images © 1960 Films 59; Portabella Films

THE HAPPY THIEVES (1961)

Museo del Prado (Paseo del Prado)

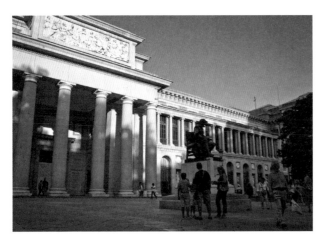
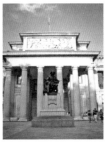

JIMMY BOURNE (Rex Harrison) is a famous thief who specializes in paintings besides being the owner of a trendy hotel in Madrid. On behalf of a Spanish aristocrat named Muñoz (Grégoire Aslan), he seizes a painting by Velazquez (*The Rokeby Venus*) with the help of Eve Lewis (Rita Hayworth) from a friend's house, where he spends the weekend. When Muñoz gets the canvas, he blackmails Jimmy and forces him to steal a painting by Goya in the Museo del Prado. In this sequence, Eve and Jimmy visit the Prado to work out the time it takes to go inside from the street to the gallery where the painting is hanging. There they stop in front of Goya's painting, *La carga de los mamelucos/The Charge of the Mamelukes* (also called *The Second of May 1808* [1814]. The picture is a companion to *Los fusilamientos del 3 de Mayo/The Third of May 1808*, which is also seen in the images). These paintings show scenes from the Spanish uprising against French invaders, during the War of Independence against Napoleon. In the present day, the Museo del Prado is one of the most visited museums in the world, thanks mainly to the collection of paintings from the sixteenth to the nineteenth century. The main attractions are Velázquez and Goya. Both masters have left a lasting mark on films made in Madrid. ↬*Lorenzo J Torres Hortelano*

(Photos © Miriam Montero)

Directed by George Marshall
Scene description: *Calculating time for the robbery of a Goya's painting*
Timecode for scene: *0:39:28 – 0:42:07*

 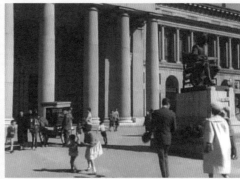

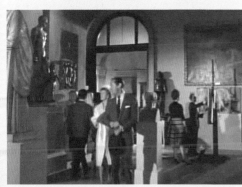 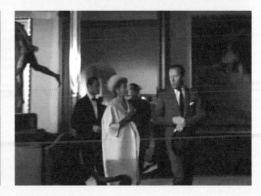

Images © 1961 Hillworth Productions A.G.

THE GREAT FAMILY/LA GRAN FAMILIA (1962)

LOCATION *Plaza Mayor*

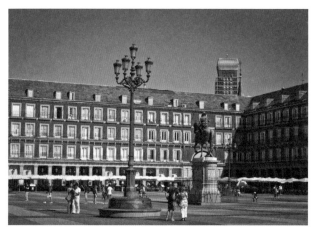

SOME SPANIARDS STILL REMEMBER Pepe Isbert´s broken voice desperately calling for Chencho, his lost grandchild, through the famous Christmas street market in the Plaza Mayor in Madrid. The movie was made in the period of Franco´s government and typically praises family values, and describes a traditional version of life's ups and downs in a large family with fifteen sons and a pleasant grandfather. The story takes place sometime in spring and it reaches a climax at Christmas, traditionally a family time within catholic culture. Plaza Mayor becomes a perfect stage for the Christmas tale turning from a play ground into somewhere more inhospitable. As night falls, Chencho does not turn up. The ambivalence among the family and the chaos of the crowd allows a perfect link with the audience, as they can identify with the restlessness and anxiety of the characters onscreen. It is a symbolic space, a situation that we can recognize as something that we have felt in the past, when we were younger and searched for our elders or, as parents, when we looked after children. Half a century has gone by since filming and the Plaza Mayor still appears much the same as in the film. Although most big cities have their ceded historic centres for public buildings and tourism, there are still emblematic places within the city where some rituals exist and mark our life. Plaza Mayor still functions as a meeting point for its citizens and, in *La Gran Familia*, achieves an intergenerational identity that helps turn the movie into a classic. ➙ *Antonio Baraybar*

(Photos © Miriam Montero)

Directed by Fernando Palacios
Scene description: '¿Dónde está Chencho?'
Timecode for scene: 1:17:38 - 1:25:34

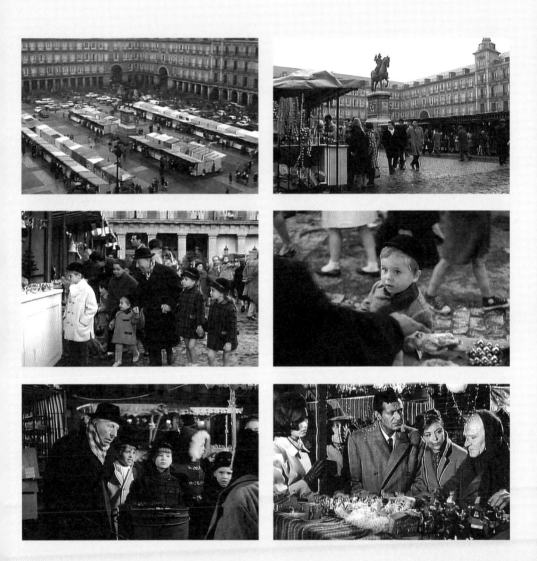

Images © 1962 Pedro Masó Producciones Cinematográficas

LIFE GOES ON/EL MUNDO SIGUE (1963)

Plaza de Chueca (Barrio de Maravillas)

BASED ON THE NOVEL of the same name written by Juan Antonio de Zunzunegui, *El mundo sigue/Life Goes On* is a bleak melodrama that presents the original material in a grotesque way, along with a certain naturalism, through an unusual visual tension (violent zooms, a constant oblique movement of the camera) with singular narrative detours. In a Brechtian style, it has a decisive point of a clear Spanish 'image-time'. The film draws a very black picture of the working classes under Franco who are frustrated and forced to live by (self) imposed, morals and empty religious words. The outward appearance, masks without content, is of waiting for money, the highest good, wherever it comes from. Towards the end, the film allows the characters and audience to see the nightmare in a developing consumer society. The jealous hatred between the two sisters culminates in Elo's (Lina Canalejas) suicide because she cannot bear sister Luisita's (Gemma Cuervo) social 'triumph': the former prostitute now happily married to a rich man. The square, the scene of the suicide, where children play in a friendly, leisurely environment is in a popular district of Madrid. The final tragic suicide shows the woman jumping from the balcony of the modest loft where her parents live, destroying the grand, luxurious and humiliating 'haiga' (big car) that Luisa brought 'to show' to the family. At first, the director conceived it as a sequence shot but in the end it could not be done due to technical difficulties. Fernán-Gómez's remarkable intuition responded to this with an ellipsis (Elo's fleeting image crowned as 'Miss Maravillas'), and a sequence shot, cut with shots of anguished faces.
↝José Luis Castro de Paz and José Ramón Garitaonaindía

(Photos © Miriam Montero)

Directed by Fernando Fernán-Gómez
Scene description: The square and suicide
Timecode for scene: 1:55:17 – 1:58:10

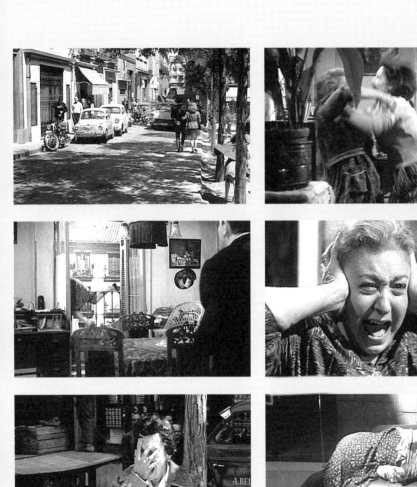

Images © 1963 Ada Films

CHIMES AT MIDNIGHT/FALSTAFF/ CAMPANADAS A MEDIA NOCHE (1965)

Casa de Campo

THIS WAS ORSON WELLES favourite film. This sequence in particular gives proof to the sentence he used to defend the importance of the editing room: 'Here is where movies are made'. Indeed, a montage so elaborate and full of rhythm meant ten days of shooting and six weeks of editing. In the film it lasts about seventeen minutes. So, in some ways, is the quintessential Welles film: a very personal project shown through the use of light; memorable performances (not only Welles as Falstaff); and the ability to deliver difficult emotional dialogue. With the passage from tragic to comic and back again without break, like where Falstaff 'witnesses' the battle, hiding among the trees with armour and sword haranguing the troops. Like a coda scene, the wardrobe designed by Welles to cut costs was stolen immediately following the film. Only a genius like Welles could turn Casa de Campo into the Battle of Shrewsbury (fought on 21 July 1403, England). No film before *Chimes at Midnight* had preparations for a battle inserted into the narrative in such detail, such as using pulleys to raise knights in heavy armour onto horses, with images of pure action in which Welles demonstrates his mastery of composition through the depth of field and montage. Casa de Campo is the largest public park in Madrid, located on the west of the city, five times larger than Central Park in New York or Hyde Park in London. The Casa de Campo contains, among other things, a lake and a zoo. But Welles' sardonic humour would perhaps have enjoyed two other interesting facts: first, that it was already inhabited in the Palaeolithic era; and, second, that since the 1990s the South of the park has become place of prostitution, despite the pressure from the Conservative government within the city. ⇥*Lorenzo J Torres Hortelano*

(Photos © Lorenzo Torres)

Directed by Orson Welles
Scene description: Battle of Shrewsbury
Timecode for scene: 0:49:40 – 1:07:46

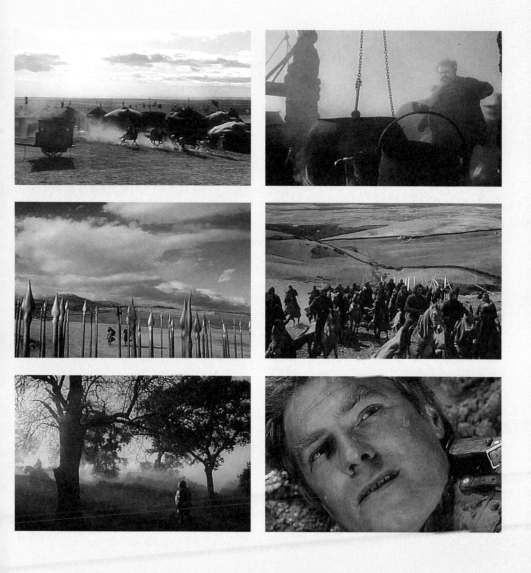

Images © 1965 Alpine Films; Internacional Films

IVÁN ZULUETA

Text by
STEVEN
MARSH

Films of Madrid's Underground

THOUGH A PROLIFIC DIRECTOR of shorts Iván Zulueta (1943–2010) – cineaste if ever there was one – made only two full-length features, one commercial, *Un, dos, tres... al escondite inglés* and the other, *Arrebato/Rapture* (1980), most definitely not. The first proved a box-office failure; the second's cult success persists to this day. Zulueta's work is radically non-conformist in its exuberant depictions of the underground urban counter culture of his generation. His two films though are also paeans – in very different ways – to the city where he lived for decades. They capture the contrasting spirit of two singular epochs in Madrid's recent history: the frivolity of the swinging sixties and the dark side of the *Movida madrileña*, the cultural boom (and with widespread intravenous drug use) that flourished in the aftermath of the death of dictator, Francisco Franco, in 1975.

A parody of the Eurovision Song Contest, *Un, dos, tres... al escondite inglés* (*Hide and Seek*, 1970) is a frenetic and light-hearted musical tour through Madrid's streets and parks punctuated by a dozen pop songs. A group of

hippy pranksters who, from their psychedelic base – the failing record shop they run – plot to sabotage the televized ceremony of the festival and supplant its selected winning song with their own choice. Its original release date of 1969 –planned to coincide with Spain's hosting of the real Eurovision Song Contest– was thwarted by the Regime and it only saw the light of day the following year with a limited release.

The sites and the sights of Madrid provide the backdrop to the film's satire. From the Regime's newsreel, superimposed on the screen of the disused drive-in (Madrid was one of only two European cities with a drive-in cinema), to the depiction of devout Christian ladies doing 'good deeds' for charity in the central Plaza de España ambushed by a group of saboteurs, or the out-of-touch and drab broadcasts of the state television company, the film mercilessly lampoons the mores and practices of the dictatorship. It also provides an indirect critique of the filmic orthodoxies of the time in Spain. Rejecting the earnest pretensions of the so-called New Spanish Cinema (promoted by liberal elements within the Regime and the Communist Party-dominated opposition) and the more traditional Spanish musical films of the 1960s, which were little more than vehicles for the promotion of singing child stars like Joselito and Marisol, it turns instead to the wacky, fast-moving pop aesthetic of Richard Lester's Beatles films, *A Hard Day's Night* (1964) and *Help* (1965).

Imbued with pop culture, its fondness for kaleidoscopic montage, zooms and quirky, jagged framing has all the freshness, (and many of the failings) of a student film project. Aptly, as if to emphasize the underground nature of the film and the surreptitious way it was able to side-step state regulations. Zu-

lueta's film school professor, José Luis Borau figures in the credits as the 'official' director: Zulueta had still not graduated and thus was not legally permitted to direct.

Zulueta would not make another full-length feature for ten years. *Rapture* is Zulueta's best-known and most celebrated film. Unlike the earlier film –with its ludic street scenes, its celebration of the open air– the Madrid of *Rapture* figures as the crucial yet sinister backdrop to an ongoing and enigmatic psychodrama concerning presence and absence, the material and the immaterial. This claustrophobic investigation takes place largely indoors, in José Sirgado's (Eusebio Poncela) mind and in his apartment on Huertas Street. Madrid – the pulsating city – lies behind the curtains, on the other side of car windscreens, through camera lenses, mirror images, or represented on the domestic screen that keeps José transfixed. A movie about filmmaking, as well as a film about heroin use, *Rapture* seeks to represent and regulate the *tempo* of obsession – the rapture – that constitutes addiction and the concomitant entropy that constantly threatens to engulf the characters, attested to by the cacophonic soundtrack that seems to pound within their heads. The veiled Madrid of *Rapture* lurks behind its shroud

either in projected, virtual form (the image of the city's emblematic Metropolis Building on the feverish roll of film that Pedro P (Will More) mails to José before his disappearance) or in the billboards of the movie theatres that line Madrid's main thoroughfare, Gran Vía. This is symptomatic of the uncanny effects of doubling that pervade *Rapture*. Madrid is present as elsewhere, as an Other, the obverse of the rank, provincial Spain. Significantly, a major part of the film is shot outside the city, at a rural farmhouse where José, as he recalls in flashback, first met Pedro P In an additional narratological strata of this multi-layered film, the name Pedro P suggests – with all its resonances of Peter Pan – a yearning for an eternal (albeit lost) childhood. The homoerotic doubling of Pedro P and José, meanwhile, dovetails with the preponderance of mirrors, the fetishization of objects, the dolls, the filmic memorabilia, the figure of Betty Boop (mimicked, in a magnificently weird performance, by José's girlfriend, Ana [Cecilia Roth]), all of which converges and climaxes in the figure of the vampire linking the two poles of cloying obsession within the film: celluloid and drugs.

Likewise, the occasional shots that reveal the bleak concrete slabs of the Plaza de los Cubos, the square beneath the flat where Pedro P mysteriously ekes out his final days, is home to many of Madrid's art-house movie theatres. We see none of that though. As Pedro P films his own disappearance in the diminutive and sordid rented apartment, the spectator's engagement with the city is, paradoxically, both drawn out and syncopated – subject to the filmic processes of montage, to the manipulations of material time and space. From time to time the silhouette of the iconic Melia Husa Hotel, looming on the skyline seen from the apartment window, locates Pedro P within the city's urban geography as he hangs his limp, transparent footage on the glass in the sunlight. Both clandestine and cosmopolitan, in this view of the underbelly of the metropolis, Madrid emerging from the margins – out of plain sight, glimpsed from side-lines, always from below, quite literally viewed through a curtain constituted by the very material of celluloid – making *Rapture* a genuinely underground film. ✦

The veiled Madrid of *Rapture* lurks behind its shroud either in projected, virtual form or in the billboards of the movie theatres that line Madrid's main thoroughfare, Gran Vía.

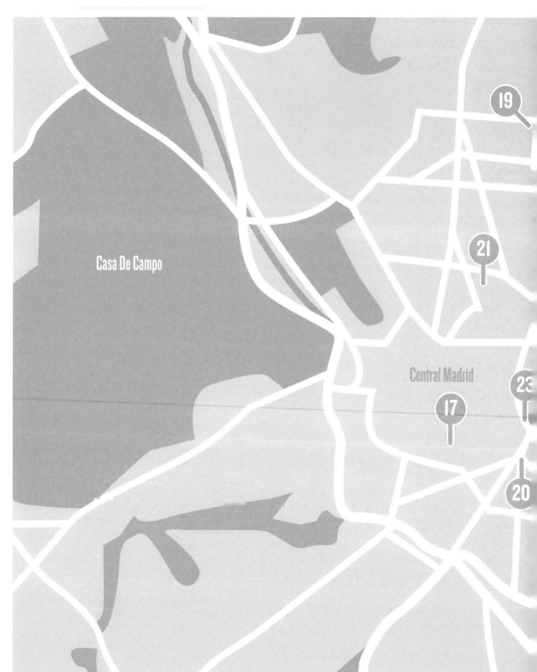

Casa De Campo

Central Madrid

19

21

23

17

20

LOCATIONS
SCENES 17-24

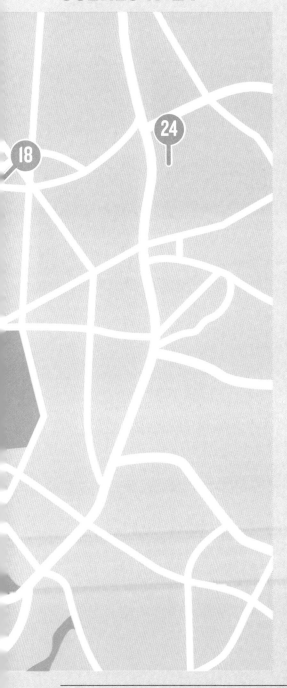

THE SEARCH/LA BUSCA (1967)

Calle Mesón de Paredes

CORRALA ('COURTYARD') is an important environment within Madrid's traditional architecture: small in size – some 30 square metres – lacking fresh air and with poor homes with shared facilities. The main entrance was through a large corridor next to a central space where private and public life was lived out. Although this kind of building was created by the architects of the sixteenth century, this sort of construction was at its height in the eighteenth century, when many migrants came from the country to the Capital. *La busca* is a screen version of the book by Pio Baroja. Both show a bleak view of the country, deeply rooted in old traditions, from the Baroque with its gloomy vision of life, to the peculiarly Spanish decline of intellectuals of *Generación del 98*. Sadness was spreading among new movie directors: a generation that took advantage of some slight liberal concessions by the political regime. The idea was to present a docile society under Franco's control where the phenomenon of migration was played out once again. The main character, Manuel, leaves his life in the country and goes to Madrid, an inhospitable, dirty, broken and dehumanized city. From the corridor of his uncle's *corrala* he sees life passing by while he waits for a future that will never come because of his nihilistic view of life. The sequence is set in a building on Mesón de Paredes street. Half a century after the book was published the place has not changed; time looks as if it has stopped in the popular Lavapiés neighborhood. But in recent years, greater optimism in Spain coincided with an interest in rebuilding the *corralas*, and some have even become National Monuments. **•› Antonio Baraybar**

(Photos © Miriam Montero)

Directed by Angelino Fons
Scene description: Life in a corrala ('courtyard')
Timecode for scene: 0:23:10 - 0:24:21

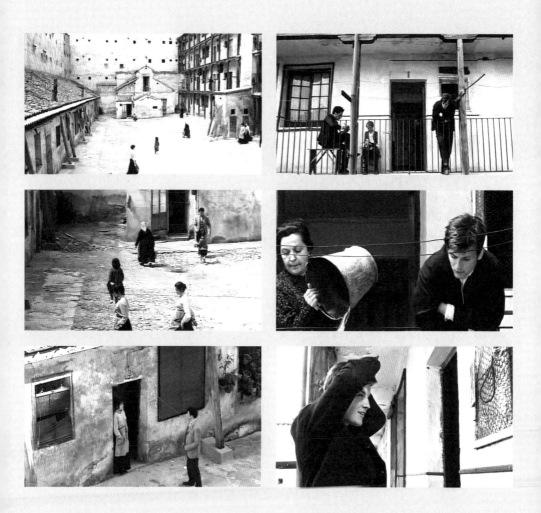

Images © 1965 Surco Films

CRIACUERVOS/RAISE RAVENS/CRÍA! (1976)

LOCATION *Calle María de Molina*

THE TITLE REFERS TO 'Cría cuervos y te sacarán los ojos' ('Raise crows and they will pull out your eyes'). The film presents the adult Ana (Geraldine Chaplin), directly to camera, remembering her childhood and her father's sudden death under natural, if bizarre, circumstances while making love to his mistress, which Ana would have heard as she listened behind the door. However, the child Ana (Ana Torrent) believes he died because she poured what she thought was poison into a glass of milk. This sequence may follow the last moments of *El espíritu de la colmena/The Spirit of the Beehive* (Víctor Erice, 1973), in which Ana stands in the doorway of the balcony where the dawn of her sexual awakening occurred. Here, Ana has thrown herself into the void, as empty and meaningless as a sexual experience through her father's infidelity. We experience a kind of hallucinatory flight through Ana's point of view over calle María de Molina (where you can see the current Instituto de Empresa, one of the world's largest business schools). This is at the northern boundary of the Barrio de Salamanca district, the most conservative in the city – as we see from the presence of Spanish flags and the luxury residential area. Ana, at the same time, plays in the garden and sees herself on the terrace: this is one of those mother/daughter splits that the director reintroduced in *Elisa vida mía/Elisa my life* (1977). Ana closes her eyes tight, covers her ears against the noise of horns and launches herself into space. The camera takes her view point, trembling, circling in the air, like the subjective point of view of a crow. Perhaps it is the gaze over a world on the verge of change, which, in 1975, was to experience the death of Dictator Franco. ➼ **Lorenzo J Torres Hortelano**

(Photos © Eduardo Hernández)

Directed by Carlos Saura
Scene description: Ana flies over the city
Timecode for scene: 0:15:43 - 0:18:06

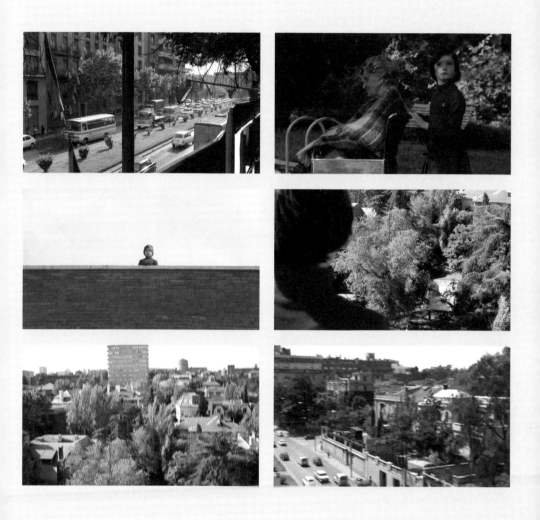

Images © 1976 Elías Querejeta Producciones Cinematográficas

ELISA MY LIFE/ELISA VIDA MÍA (1977)

LOCATION *Paseo de la Castellana, Nuevos Ministerios, 'El Corte Inglés'*

WITH *ELISA, VIDA MÍA*, Fernado Rey won the Best Actor award at Cannes for his role as Luis, a professor and frustrated writer who leads an ascetic life in a little town in Segovia – relatively close to Madrid. His daughter Elisa visits him after many years and they revive a loving parent-child relationship that develops into incestuous desire, at least in the parallel world of dreams proposed by Saura. 'Elisa, vida mía' comes from a sonnet by Garcilaso, and Elisa is an anagram of the name of de la Vega's platonic love, Isabel Freyre. For Luis, Elisa represents an imaginary threshold that he is unable to cross. But, by holding himself back, he does not let Elisa go, so she is compelled to stay with him and dream those shared incestuous fantasies. Here is where Madrid appears for the first and last time in the film – in parallel editing. As a counterpoint to the father's immovable space where they chat, Elisa wanders around the hectic city, amongst the crowds and cars, suffering its absurdity. She buys a pair of glasses in a mall and then throws them into a litterbin; she goes down into the subway, like a descent into hell. In another scene she is captivated by a blind woman sitting in a wheelchair and cannot stop staring at her – one of the various reminiscences of the myth of Oedipus that are scattered all over the film, showing that Elisa has not yet overcome it. Along these lines, the last image shows the horizon where a door is drawn, through which Elisa could pass but finds difficult because of a blinding backlight. **↝Lorenzo J Torres Hortelano**

(Photos © Eduardo Hernández)

Directed by Carlos Saura
Scene description: Story of Elisa's disappointment
Timecode for scene: 1:05:37 – 1:15:45

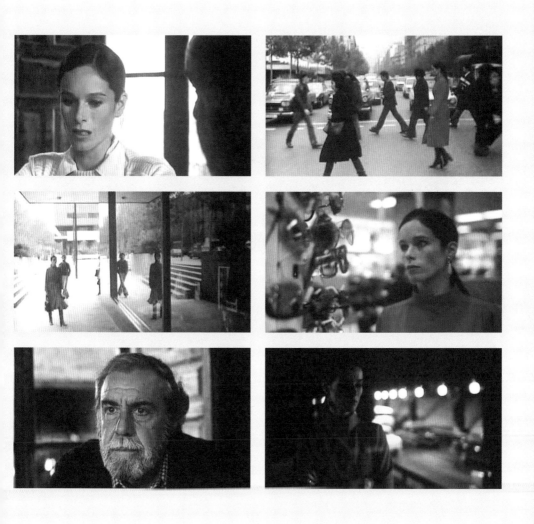

Images © 1977 Elías Querejeta Producciones Cinematográficas S.L.

THAT OBSCURE OBJECT OF DESIRE/ ESE OSCURO OBJETO DEL DESEO (1977)

LOCATION *Estación de Atocha*

DURING A TRIP BY TRAIN, Faber Mathieu (Fernando Rey) tells his compartment fellows his history with Conchita, (played by Ángela Molina and Carole Bouquet), an arractive woman he has been trying to seduce. However, she always manages to escape his attempts, but still gives him hope. One of the curious elements of this film is that Buñuel used two actresses for the same character of Conchita, the actors alternating the role between sequences, sometimes within the same scene: another challenge from the master of surrealism. Buñuel also extends this surreal ambivalence to other scenes – for example, when the couple (with Ángela Molina) arrive by train at Estación de Atocha; they catch a taxi as if to drive through the streets of Madrid, but, seamlessly, without a break, we see the couple (now with Carole Bouquet) walking around Paris. The image of the powerful black locomotive with which the sequence starts could be seen as the image/symbol around which the title of the film crystallizes. Most of the images in the sequence have a cold documentary-style, derived from the dissolution of the narrative structure of Buñuel's cinema. It may also, as a sort of premonition, allow us to honour the victims of the infamous terrorist attack of March 11, 2004, which resulted in 191 deaths and 1858 injuries. Currently, Estación de Atocha is the largest and most modern railway complex in Spain and the area, known as 'Atocha', is one of the most popular and busiest places in Madrid, with the Museo de Arte Reina Sofía (MNCARS), and it is where the Paseo del Prado begins. ➻**Lorenzo J Torres Hortelano**

(Photos © Eduardo Hernández)

Directed by Luis Buñuel
Scene description: A taxi ride through the city
Timecode for scene: 1:38:13 – 1:39:11

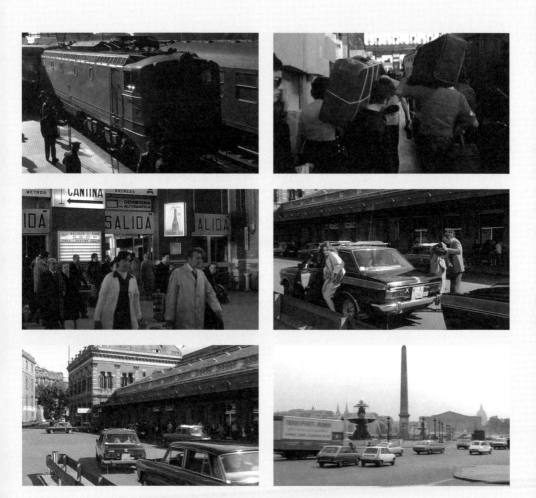

Images © 1977 Greenwich Film productions; Les Films Galaxie; In-Cine Compañía Industrial Cinematográfica

UNFINISHED BUSINESS/
ASIGNATURA PENDIENTE (1977)

LOCATION *Calle Barceló, Tribunal area*

UNFINISHED BUSINESS is the first feature film by JL Garci – who won an
Oscar for *Begin the Beguine* (1982), which broke attendance records. His cinema
is a kind of sentimental memory of the generation that was in their 40s in La
Transición (starting in 1975). *Unfinished Business* is usually considered a key
film of that period, as an inner story of the miracle of democracy through the
love story of José (José Sacristan), a communist lawyer, and Elena (Fiorella
Faltoyano). Teenage sweethearts, they meet each other by fate on the street a
few years later. They relive their love, but now both are married with children.
Throughout the film there are very recognizable places in and around Madrid.
In this scene, at the beginning of the film, we see the chance meeting of the
protagonists in Tribunal ('Court'), an area near the Palacio de Justicia, where
José works. The sequence begins with a title overlay, '1 de octubre de 1975' (1
October 1975), the day dictator Franco gave his last public speech in Plaza de
Oriente. There is a blowing of horns and waving of the Spanish flag in Franco's
honour (an action now used to celebrate football victories). José represents
a new generation of Spaniards whose boundless energy seduces Elena once
again. However, through the greyness of Madrid's streets they have to confront
a frustrated society that deprived them of so many things. When José calls
out to her in the the street her face lights up, but everyone around is taken
aback. An absurd and significant thing about the Dictatorship was that even a
public display of joy could be considered scandalous. The death of Franco on 20
November of that year is also shown. After 39 years of dictatorship, Spain was
left with the unfinished business of democracy. **⇢Lorenzo J Torres Hortelano**

(Photo © Eduardo Hernández)

Directed by José Luis Garci
Scene description: Elena and José reencounter
Timecode for scene: 0:10:53 – 0:12:08

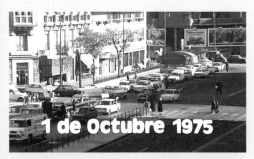

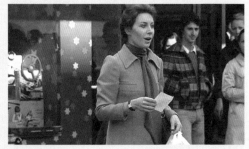

Images © 1977 José Luis Tafur P.C.

MARAVILLAS (1980)

The rooftops of central Madrid

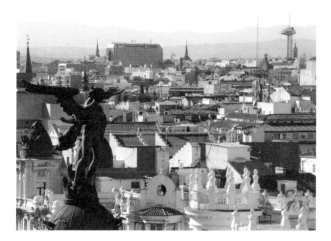

ON THE DAY OF HER FIRST communion Maravillas' (meaning 'wonders' and played by Cristina Marcos) Sephardic Jewish godfather Salomón (Francisco Merino) rewards her with a mysterious ring. To obtain the gift Salomón tells her she must walk along the vertiginous strip of wall that lines the terrace above the apartment where she lives with her father. It is a scene that sets the tone for the film to come, a delicate, risky balancing act between the mundane and the marvellous. The stunning shots of the city centre on rooftops at dusk, the harshness of the declining summer sun constitute the scene's urban backdrop. The sequence begins when Salomón makes a cryptic sign to Maravillas from behind the latticework that divides the terrace. *Maravillas* is a film about enigmas, about the mysteries of representation and the power of illusion, whether filmic, religious or magical. The high angled shots of the dilapidated patio below in combination with the inserted shots of Maravillas' anxious father, Fernando (Fernando Fernán-Gómez), and his friends staring alarmed from beneath the wall, point up the film's psychic relations. The neutral shot-reverse shots between Salomón and Maravillas confirm their secret complicity in the face of neurosis, the pathological fear that afflicts and paralyses the other characters. The sequence draws upon the Jewish and Christian cultural roots of Spain: a Spain poised between the cosmopolitan and the sacred. **➥Steven Marsh**

(Photo © Alicia G. González)

Directed by Manuel Gutiérrez Aragón

Scene description: Maravillas walks along the wall above her apartment
Timecode for scene: 0:05:53 – 0:08:34

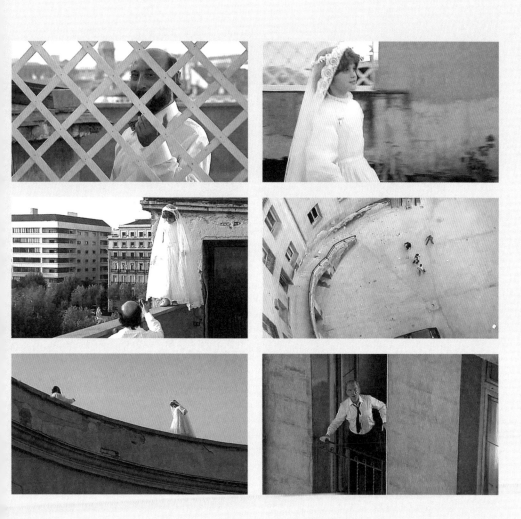

Images © 1980 Arandano S.A.

BICYCLES ARE FOR THE SUMMER/
LAS BICICLETAS SON PARA EL VERANO (1984)

LOCATION *Cuesta de Moyano (Calle de Claudio Moyano)*

BASED IN THE NOVEL by Fernando Fernán-Gómez, the story begins in the summer of 1936, at the outbreak of the Spanish Civil War, in the centre of Madrid. A Republican middle-class family, Don Luis (Agustín González), his wife Dolores (Amparo Soler), and their children, Manolita (Victoria Abril) and Luisito (Gabino Diego), share the miseries of war with the maid and neighbours of their building. Luisito fails his exams, but he still wants his father to buy him a bicycle. Unfortunately, as the war will last much longer than expected, the situation will force the postponement of the purchase. But, despite the miseries of war, life and desire goes on: Julio (Carlos Tristancho), the son of a conservative neighbouring family, falls for the beautiful Manolita and courts her, although, as shown in this scene, she is not interested in him. Julio apologizes. The scene occurs at Cuesta de Moyano, famous for its book stalls at the gate of the Jardín Botánico (the Botanical Gardens). This popular street links the Paseo del Prado to Parque de El Retiro, and nowadays is pedestrianized and still has the stalls. We see Manolita looking for plays because she wants to be an actress. Julio, in a histrionic way in front of all passers-by, loudly asks her to marry him, so she will not have to work anymore (she will eventually marry him to help the family). This financial incentive reverberates because, in Cuesta de Moyano, they sell second-hand books, and in the fact that, as with other broken lives in the Civil War, Julio will finally die during a bombing of Madrid. **➔ Lorenzo J Torres Hortelano**

(Photos © Eduardo Hernández)

Scene description: Julio declares his love for Manolita
Timecode for scene: 0:24:43 – 0:26:43

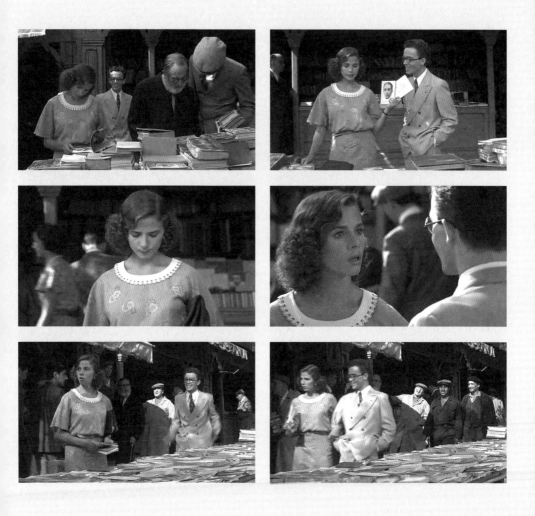

Images © 1984 Impala; In-Cine Compañía Industrial Cinematográfica; Jet Films

WHAT HAVE I DONE TO DESERVE THIS?/
¿QUÉ HE HECHO YO PARA MERECER ESTO!! (1984)

LOCATION *Barrio de la Concepción*

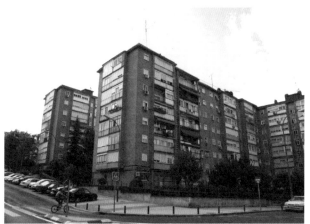

ALMODÓVAR'S FILM, made from scraps of Spanish popular culture such as the black comedies of the 1950s and 1960s, is the portrait of the miserable daily life of a housewife on the outskirts of Madrid. The film, uniquely reflective, is not only a rigorous discourse on the possibility of a family configuration different from the traditional one, which is now outworn, but connects directly with the remarkable *Surcos/Furrows* (Nieves Conde, 1951). It also has rudimentary neorealist elements and the migration from the country to Madrid now becomes a distorted picture of marginalization and alienation, loneliness and frustration of a rural proletarian class barely able to cross the border into the city proper (thus the grey and uninhabitable hives of the Barrio de la Concepción). No less striking is the connection of *¿Qué he hecho yo para merecer esto!!/What Have I Done to Deserve This!* with one of the Spanish films most admired by Almodóvar: *El extraño viaje/ Strange voyage* (Fernán-Gómez, 1964), a 'melodrama' that, far from the official aim of giving visibility to a cultured and developed Spain, draws a blackly comic picture of the essentially misplaced Spaniard's life. Anonymous puppets living with a monster they call Money, only observed by appliances or watched in amazement from the shops, surrounded like caged animals by tacky and kitsch decoration, the characters played by Carmen Maura and Chus Lampreave — Iberian and with eccentric voices and imperfect bodies — are dissected 'from above' with the distant and godlike detachment that Valle-Inclán, nineteenth century writer, had talked about. In addition, just like Fernán-Gómez, Almodóvar succeeds in hybridizing his native cultural references with a crime plot taken, without apology, from Alfred Hitchcock's telefilm *Lamb to the Slaughter* (1958). **↝José Luis Castro de Paz and José Ramón Garitaonaindía**

(Photos © Lorenzo Torres)

Directed by Pedro Almodóvar
Scene description: *Morning shopping in the neighbourhood*
Timecode for scene: *0:27:29 – 0:30:40'*

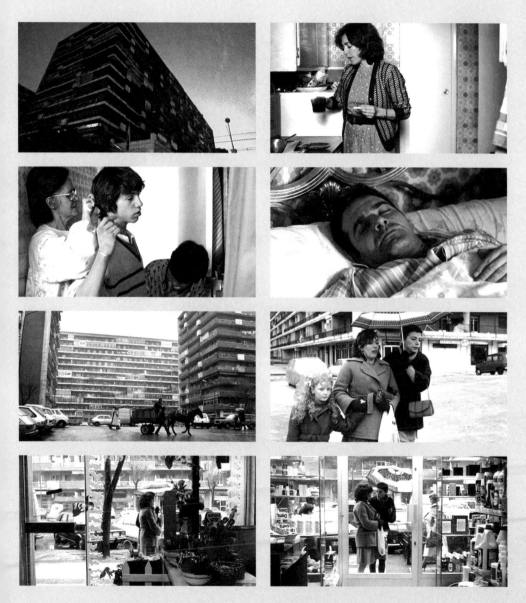

Images © 1984 Kaktus Producciones Cinematográficas; Tesauro S.A.

EMBRACING NORMALCY

Text by
HELIO SAN
MIGUEL

Madrid's Gay Cinema at the Turn of the New Millennium

ONE OF THE MOST distinctive features of the cinema of Madrid (and Spain) at the turn of the new millennium is the significant crop of films related to gay themes. In just three decades Spain has experienced a startling change: from being quite a homophobic culture to becoming, in 2005, the third country in the world to legalize gay marriage and the first to do so with full adoption rights. Gay characters and issues went from almost total absence or merciless mockery during the Franco and *Transición* years to an underground curiosity in the early years of democracy represented by Madrid's *La Movida* and Almodóvar, leading to a normal and recurrent presence in current mainstream cinema and in Madrid's urban culture.

Nothing exemplifies this process of normalization better than the rapid transformation of Chueca. Once a rundown area in the centre of the city until the gay community started moving there, it has quickly become a hip neighborhood and the beating heart of gay Madrid. *Spinnin'*, a commendable, quirky and whimsical movie set in 1995, epitomizes this change. At

that time the gay community still suffered occasional attacks in Chueca, the AIDS scourge was visible and marriage and adoption rights were goals to fight for. A character in *Spinnin'* says, 'The world is already filmed. Now we need to change it.' But, when the movie was made in 2007, many of those aspirations had already become a reality, and the film served more as a testimony of the change. That year Madrid was the site of *Europride*, and Chueca had already become a chic residential area, a hot nightlife destination and the foremost film set of gay Madrid.

Countless movies have helped define the ethos of this normalization in the last fifteen years. Madrid is shown as the anonymous city where a tormented Alberto in the remarkable *Segunda piel/Second Skin* (1999) can keep secrets and separate relationships with a gay lover and a wife. However, for the most part, Madrid appears as a big, open, joyful and diverse metropolis where, as *Km. 0* (2000) shows, a myriad coupling combinations can happen. Madrid is where Marcos, the leading character in *I Love You Baby* (2001), comes to explore his homosexuality. When his boyfriend kisses him in broad daylight, he asks surprised '¿Aquí, en la calle?' ('Here, in the street?'); a place where according to *Amor de hombre/The Love of a Man* (1997) all men, may they be waiters, cab drivers, musicians, doctors, pet store owners, lawyers, or even married, are gay. Some form stable relationships and quarrel about domestic issues, while others just cruise the city in search of easy hook-ups. Madrid is also the city where young male immigrants in *Los novios búlgaros/Bulgarian Lovers* (2003) become sex toys for promiscuous and liberated, well-off gay professionals who live in modern homes, populate upscale spas, use

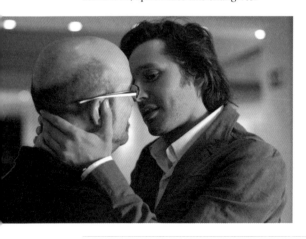

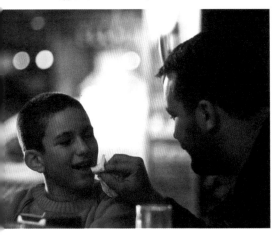

drugs freely, drink expensive wine and party in Chueca. Finally, in *Reinas/Queens* (2006), produced in the middle of the debate over the landmark gay marriage law, Madrid is above all the site of the historic event of the first twenty gay weddings.

But this normalization has also gone one step further, leading to questions about typical gay stereotypes in favour of a depiction of characters that happen to be gay and have a different lifestyle, but also share other problems with the rest of society. This change is first evident in *Cachorro/Bear Cub* (2004), fully addressed in *Chuecatown/Boystown* (2007), and has gone full circle in *Fuera de Carta/Chef's Special* (2008).

In *Bear Cub*, Pedro, an HIV-positive gay dentist with an active and promiscuous sexual life, suddenly finds himself as the guardian of his 9-year-old nephew. The movie doesn't make apologies for his lifestyle and the ones of his friends, a group of mostly middle-aged gay men holding regular jobs and carrying on normal lives. *Bear Cub* asks us to embrace their normalcy, not yet fully accepted (in fact, the director deleted a couple of scenes that could have been perceived as taking it too far), by showing a community that faces the same emotional insecurities and day-to-day problems as

everyone else. In a statement the director added to the DVD, he recognized that his goal is for normalization beyond gay stereotypes, even socially accepted ones, and to try to address real problems. When the grandmother, armed with prevalent and opposing social values, blackmails Pedro by threatening to make his HIV condition public if he doesn't let her take the boy, it is the child who, in a moving scene, shows her that accepting that normalization is a tough but achievable goal.

In *Boystown*, Víctor, a good-looking, fashion-conscious, gym-addicted, gay real estate agent, buys dilapidated houses in Chueca, even killing old ladies who refuse to sell, in his aesthetic and social mission of turning the area into a modern minimalist habitat for affluent gay clients. He sets his eyes on an apartment inherited by Ray, a plumber, who lives with his partner Leo, a driving-school teacher. Both are far removed from Víctor's glamorous world. When he tries to entice Leo away from Ray, Leo is easily dazzled by the parties and art shows where the crowds seem like those straight out of an Almodóvar movie. But in the end, the killer is exposed, Leo reconciles with Ray, and both return to and embrace the normalcy of their working class lives.

Maxi, in *Chef's Special*, is a successful gay chef obsessed with sophisticated dishes and consumed with obtaining a Michelin star for his Chueca restaurant, Xantarella. Maxi was previously married but abandoned his wife and children when he came out of the closet. When she dies he reluctantly has to take care of his neglected kids. The struggle with his teenage son makes Maxi realign his life's outlook and transforms him. In the final sequence, Maxi is seen quickly giving some instructions about traditional dishes before taking the day off with his kids and his partner, a former football player. Then we see that Xantarella has morphed into Casa Xantarella, a home-style restaurant.

In the current cinema of Madrid, society is not only accepting the presence of the gay community, but it is also promoting and embracing a new normalcy that goes beyond sexual orientation and some persistent and pervasive stereotypes. ✢

In the current cinema of Madrid, society is not only accepting the presence of the gay community, but it is also promoting and embracing their lifestyles.

N

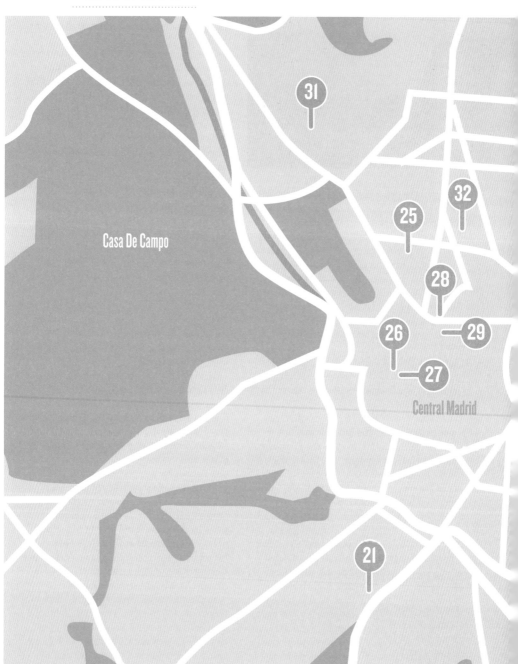

Casa De Campo

31

32

25

28

26 29

27

Central Madrid

21

LOCATIONS
SCENES 25-32

LAW OF DESIRE/LA LEY DEL DESEO (1987)

LOCATION *Calle Conde Duque, 11*

CONSIDERED TO BE Considered to be Almodovar's first explicit gay film, it focuses on a dramatic love triangle: Antonio (Antonio Banderas), a homosexual obsessed with Pablo (Eusebio Poncela), a film director, who is in love with Juan. Antonio kills Juan and takes advantage of Tina (Carmen Maura), Pablo's transsexual sister, to get back at Pablo. Several places are fully recognizable throughout the film, with the characteristic Almodóvar aesthetic of bright colours with the backdrop of *La Movida*. The most memorable scene, almost in the middle of the film, is the one that takes place in front of the cultural centre called *Cuartel del Conde Duque*. Tina, Pablo and a nephew walk during a summer night through the suffocating, vibrant Madrid, but one also in construction. A municipal employee waters the streets and Tina, taking the opportunity to cool off, goes to a gap in a wall and hisses at the man: 'Come on, water me up!'. The sexy image of Carmen Maura soaking wet on a hot Madrid night is one of the Almodóvar icons, as well as for *La Movida*, and we could say, for the whole of Spanish cinema. All of this in an era in which the first generation after the dictatorship was living in a kind of strange utopia. The phallic streaming hose is also a shout of freedom in front of the main entrance of *Cuartel del Conde Duque*. 'Cuartel' means 'barracks'; the sixteenth-century and the Conde Duque de Olivares is known as an authoritative minister whose tax reforms led to riots. These are, therefore, also the images that sum up the film's title. As Almodóvar said: 'Yo creo que es la imagen que mejor representa eso que llamamos deseo' ('I think it is the image that best represents what we call desire'). **•Lorenzo J Torres Hortelano**

(Photos © Miriam Montero)

Directed by Pedro Almodóvar
Scene description: *Water me up!*
Timecode for scene: *0:42:52 – 0:44:16*

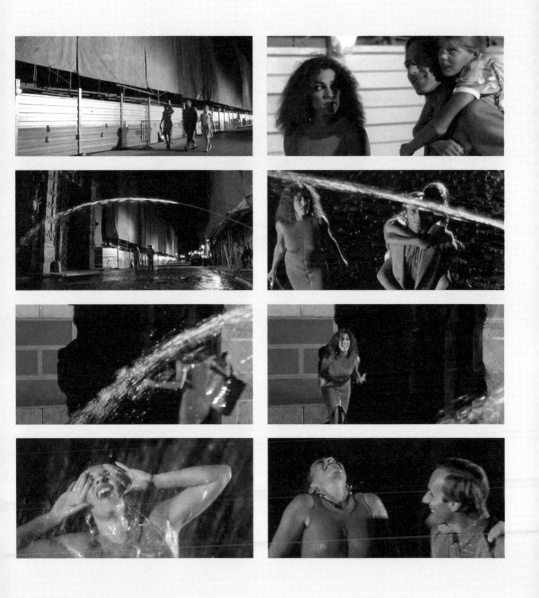

Images © 1987 El Deseo S.A.; Laurenfilm

SIESTA (1987)

LOCATION *Arco de Cuchilleros*

CLAIRE (ELLEN BARKIN) has flown from California to Madrid to track down her former tightrope trainer, Augustine (Gabriel Byrne), who has married a local woman (Isabella Rossellini). Here she meets a gang of eccentric British people at a photography exhibition and ends up having dinner with the group, which features, among other odd-behaving characters, Nancy (Jodie Foster) putting her leg around Kit's (Julian Sands) neck at the dining table while his wife Des (Anastasia Stakis) looks on. However, Kit fancies Claire and, once the flamenco show has started, helps her sneak out of the restaurant by pretending they are part of the dance troupe after two dumb policemen have stormed in seemingly looking for her. Only when they get outside do we realize that they are leaving *Las Cuevas de Luis Candelas*, a popular restaurant next door to the Arco de Cuchilleros, an arch that leads up to the Plaza Mayor. They are standing there when Kit asks her to go to the hotel with him, then we get a full shot which conveys the beauty of the arch and the walking space around it. Here, improbably, they are overtaken by the flamenco dancers and the customers pouring out of the restaurant; the policemen are now nowhere to be seen now. But, suddenly, the clock in the square strikes 5 a.m. (!), Claire, astounded, conjures up: 'I killed someone. I'm in love with a man and I killed his wife'. 'How extraordinary!', he replies. The urban landscape certainly is. ➻ *John D Sanderson*

(Photos © Miriam Montero)

Directed by Mary Lambert

Scene description: *Claire's confession at the Arco de Cuchilleros*

Timecode for scene: 0:29:31 – 0:34:37

Images © 1987 Palace Pictures; Siren

TIE ME UP! TIE ME DOWN!/¡ÁTAME! (1990)

Plaza de la Villa, Madrid

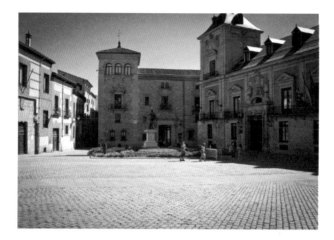

AS USUAL IN ALMODÓVAR'S CINEMA, this film celebrates the schizophrenic mix of tradition and modernity that informed *La Movida*. At the start, having being released from a mental institution, the main character Ricky (Antonio Banderas), takes to the avenues, which swarm with multi-cultural crowds. The characteristic zoom lens captures its environment: a harmonic, if gaudy blend of traditional stores, bullrings and other traces of the most genuine and cheesy images of Spain. Rather empty, and choking under the sun of a long August weekend, the capital is in the process of 'modernization'. We also see the mock-out of a studio where the protagonists of the film 'Midnight ghost' are working and in fact it is no longer possible to tell the natural from the artificial in this motley group of elements including the classical, the modern and the typically Almodovarian pastiche. Grilles of stately buildings, old elevators and staircases with large windowpanes and wooden banisters are easily replaced with interiors decorated in a *kitsch* fashion, boasting splendid views over the Madrid de los Austrias as the one which Máximo Espejo's (Paco Rabal) balcony overlooks, but are also seen from Marina Osorio's place (Victoria Abril, the other protagonist) in Calle Bordadores. This is all very well; it is colourful and fun, but the true story develops in the squares of the Barrio de Chueca, where a drug-dealing Rossy de Palma and her cronies loiter. Vespas ride down dingy streets, whose walls are crusty with graffiti of Nazi symbols; there are unmistakable cabs of the capital and the urban cleaning vehicles that contribute to cooling down the stifling nights which gives respite to its inhabitants, as they do to that poor bastard Ricky, after he is beaten up. ➻ *Agustín Rubio Alcover*

(Photos © Miriam Montero)

Directed by Pedro Almodóvar
Scene description: *The thrashing*
Timecode for scene: 1:07:30 – 1:11:00

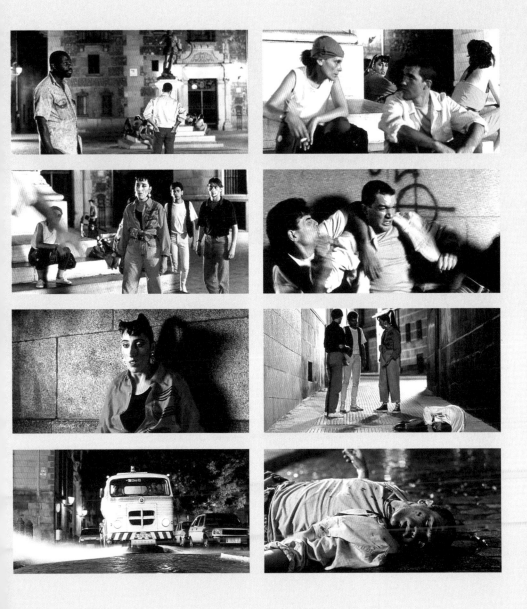

Images © 1990 El Deseo S.A.

THE DAY OF THE BEAST/EL DÍA DE LA BESTIA (1995)

Schweppes Building (Carrión or Capitol), Gran Vía and Plaza de Callao

THE DAY OF THE BEAST established Alex de la Iglesia as a director, winning both audiences and critics with this 'satanic comedy'. A Basque priest and professor (Alex Angulo) believes he has deciphered the secret message of the Revelation of St John: the Antichrist will be born on Christmas Day 1995 in Madrid. To prevent the birth of Satan's son, the priest joins forces with José Maria (Santiago Segura), a young fan of heavy metal. Both try to figure out where in Madrid the apocalyptic event will take place. With the help of Professor Cavan (Armando de Razza), host of a television programme about the esoteric and supernatural, and the priest José María, like some sort of inverted Three Wise Men, invoke the devil in a strange ceremony. The film is a mix of genres: horror, crime, science fiction and, above all, comedy. Of which the perfect example is Santiago Segura (a media figure in Spain) hanging from one of the most famous city buildings, the Edificio Schweppes, also known as Carrion or Capitol. At the confluence of several streets, it is one of the most touristic sights, and this is surely one of the most spectacular action sequences that has ever been filmed in Gran Vía in Madrid. Edificio Schweppes dates from 1931–33, and is in the art deco style – not so far from the style of comics which marks the film. The bright neon of the Schweppes brand is one of the symbols of the Gran Vía and of the city itself, and has appeared in many films. **➥Lorenzo J Torres Hortelano**

(Photos © Eduardo Hernández)

Directed by Alex de la Iglesia
Scene description: Escape on the Schweppes Building
Timecode for scene: 1:04:23 – 1:06:34

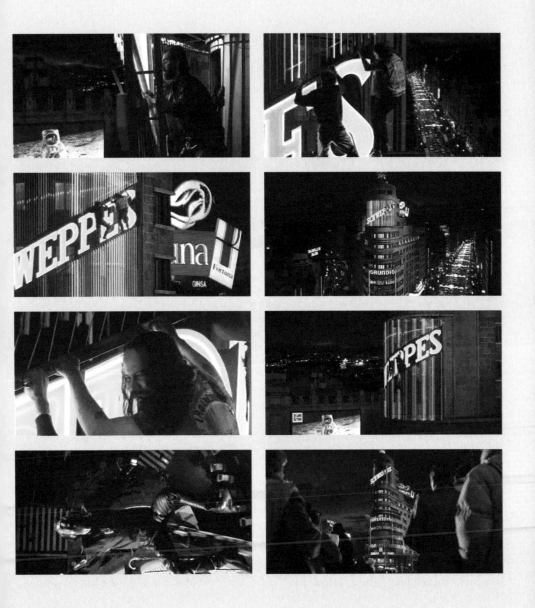

Images © 1995 Canal+ España; Iberoamericana Films Producción; Sociedad General de Televisión

THE FLOWER OF MY SECRET/ LA FLOR DE MI SECRETO (1995)

LOCATION

Plaza de Callao and Edificio FNAC

AFTER PULLING BACK a zebra skin curtain (very kitsch, very Almodóvar), there begins a fantastic sequence (this is one of the most technically successful of Almodóvar's films) with a descending shot. We see the Madrid skyline, the building known as FNAC (selling popular books, DVDs, etc.), as the camera tracks down to the street with typical red buses and people walking through Plaza de Callao. Only now do we realize that we are inside a penthouse where Leo (Marisa Paredes), a writer of romantic novels, dozes. She has been forsaken by her military husband (Imanol Arias). Soon, Ángel, her new publisher who has fallen in love with her, appears in the penthouse and admits that he knows 'the flower of [her] secret'. The day before, Leo had tried, unsuccessfully, to commit suicide with pills, while wandering through the streets of Madrid and Ángel rescues her from a strike protest by doctors. The extradiegetic melodramatic song 'Ay amor' – written and performed by Ignacio Villa (Bola de nieve') – which is heard towards the end of this strike scene is bridged back to the penthouse: 'Amor, yo sé que quieres / Llevarte mi ilusión / Amor, yo se que puedes también / Llevarte mi alma / Pero, ay amor, si te llevas mi alma / Llévate de mí también el dolor ...': 'Love, I know what you want / To take my dream away / Love, I know you can also / Take my soul / But, oh my love, if you take my soul / Take my pain too...'. It is Leo's pain that fades out on the skyline of Madrid. So, this epiphany is crystallized into the huge FNAC poster that announces her new book, *Antología* (*Antohology*), where the audience should work out the *Flower of Her Secret* (like Almodóvar's') in the most public place of Madrid. **↦Lorenzo J Torres Hortelano**

(Photos © Eduardo Hernández)

Directed by Pedro Almodóvar
Scene description: Epifanía de Leo
Timecode for scene: 1:04:23 – 1:06:34

Images © 1995 CiBy 2000; El Deseo S.A.

NOBODY WILL SPEAK OF US WHEN WE'RE DEAD/
NADIE HABLARÁ DE NOSOTRAS CUANDO HAYAMOS MUERTO (1995)

LOCATION *Plaza de Toros Monumental de las Ventas*

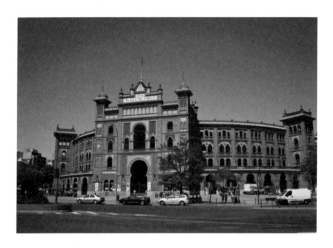

THIS IS, PERHAPS, the best thriller in Spanish cinema of the 1990s, shot almost entirely in Madrid (the epilogue takes place in Mexico). Specifically, it is a film noir, meaning that the characters naturally cross the boundaries between good and evil. It is heavily influenced by Scorsese – the director has declared that he watches all Scorsese's movies when he plans a new film – but with a genuine taste of Madrid, as the city is generously displayed throughout the story. But the essential symbol for this film is the Plaza de Toros de las Ventas, where Gloria's husband had been a banderillero (in the opening sequence we see him severely gored, and he is then permanently bedridden) and which is the first thing Gloria (Victoria Abril) sees when she returns to Madrid: She had worked as a prostitute in Mexico and she is also involved with a Mexican cartel. Paco Fomenía, the cinematographer who also worked on *Solo quiero caminar* (Díaz Yanes, 2008) makes the light speak to the audience in two short minutes, when, after three years in Mexico, Gloria returns to Madrid and we go from the realistic light of the customs, to the bright and touristy light of the Las Ventas sky, through the intimate and thinned light reflected in the bus window (which speaks of her despair which originated in the misfortune of her husband), to the shrill red light reflected off the bus. The nightmare is recalled, we assume, in the reflection of the great Moorish gate of Las Ventas, called *Puerta Grande*, from which only successful bullfighters leave like gladiators, on the shoulders of their public. Las Ventas is the most important bullring in the world, dating from the nineteenth century, although its current configuration is from 1931. Since the 1960s it has also been a venue for musicians such as The Beatles, AC/DC, The Cure and Shakira. •➤*Lorenzo J Torres Hortelano*

(Photos © Miriam Montero)

Directed by Agustín Díaz Yanes
Scene description: Gloria is deported and returns to Spain
Timecode for scene: :14:31 – 1:06:34

 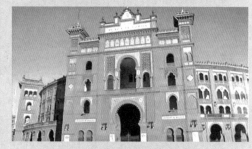

Images © 1995 Canal+ España; Creativos Asociados de Radio y Televisión (CARTEL); Flamenco Films S.A.

THESIS/TESIS (1996)

'Doce de Octubre' subway station and Facultad de Ciencias de la Información (Universidad Complutense de Madrid)

THE SUBWAY IS BEING EVACUATED because a person has just committed suicide by jumping onto the tracks. The security guards instruct everybody to leave in an orderly fashion and request that they do not look because the body has been cut in half. Ángela (Ana Torrent) is walking in the line of people but something pulls her towards the tracks. She is hesitant and does not want to look, but the dead body keeps beckoning her. Finally, she cannot resist; she steps out of line and tries to take a quick look. The camera, acting as Ángela's eyes, tries to glance at the body among the crowd. The director cuts to Ángela's face before a security guard pulls her away. We do not see the disfigured body, but we sense that she has glanced at it. The next scene begins with an eerily similar camera movement over the concrete railing of the university's film school, where Ángela studies. This first scene and the transition to the concrete railing in the next scene set the tone of the story and are central to the character. Violent scenes morbidly attract Angela and that curiosity will put her life at risk. The Madrid underground will end up being less dangerous than her charming classmates, upper class apartments and, especially, the non-descript school building. We will soon find out that it hides its own underground space: a secret storage place full of tapes with horrible crimes that will again ignite Ángela's gruesome curiosity. It is certainly ironic that a Madrid film school, famous in Franco's time for its resistance against the dictatorship, is now a place where the most hideous crimes are planned and recorded on tape. **�»Helio San Miguel**

(Photos © Eduardo Hernández)

Directed by Alejandro Amenábar
Scene description: The subway is evacuated after a passenger jumps onto the tracks
Timecode for scene: 0:00:12 – 0:02:10

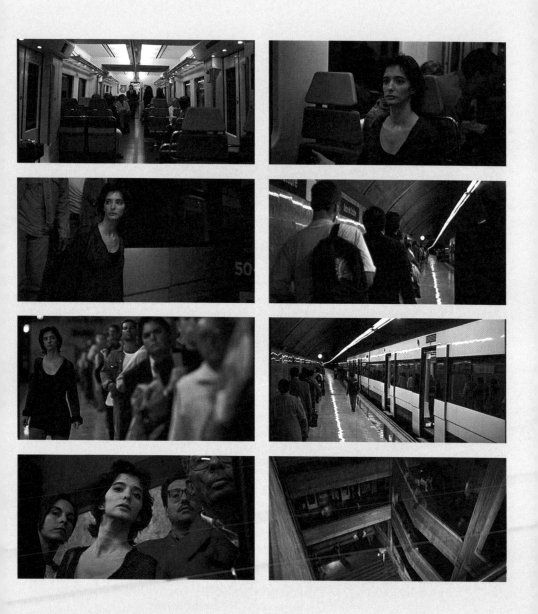

Images © 1996 Las Producciones del Escorpión S.L.

NEIGHBORHOOD/BARRIO (1997)

LOCATION *Metro track between the stations of 'Iglesia' and 'Bilbao'*

HAVING MISSED THE LAST underground train from the centre back to their neighbourhood in the outlying reaches of Madrid, Manu, Rai and Javi, (Eloi Yebra, Críspulo Cabezas and Timy Benito), decide to walk home through the tunnels that constitute the city's Metro system. This sequence is symptomatic of *Barrio*'s charting of the bleak underbelly of Madrid's mutating topology. Emerging from out of the darkness, the three adolescents stroll bewildered through the disused station of Chamberí, abandoned decades before and now home to clandestine African immigrants. It is a scene of abjection, to those excluded from the world of daylight, a 'ghost' station inhabited by the living dead – spectral denizens condemned to the shadowy depths of Madrid –, excluded and denied citizenship. This almost wordless sojourn is accompanied by Cheb Mami's haunting melody, punctuated occasionally by the sound of a baby's cry. Both rail tracks and tunnels are recurring motifs throughout the diegesis of this film. The poetry of the scene's cinematography provides a wry contrast to the squalid conditions that point up the grim and sordid realities of globalization. A further irony – part of its central conceit – lies in the fact that Chamberí is a district celebrated in popular culture for its purported autochthonous characters, as an area that purports to exemplify the very 'essence' of traditional Madrid. *Barrio*'s politics turn on elements of the local and the global as they coincide and contradict one another within the space and landscape of Madrid. It is a film that reveals the hidden consequences of the much-vaunted urban planning initiatives promoted by successive right-wing city governments. **↝Steven Marsh**

(Photos © Lara Pérez)

Directed by Fernando León de Aranoa
Scene description: The ghost station of Chamberí
Timecode for scene: 1:07:2 0 – 1:10:03

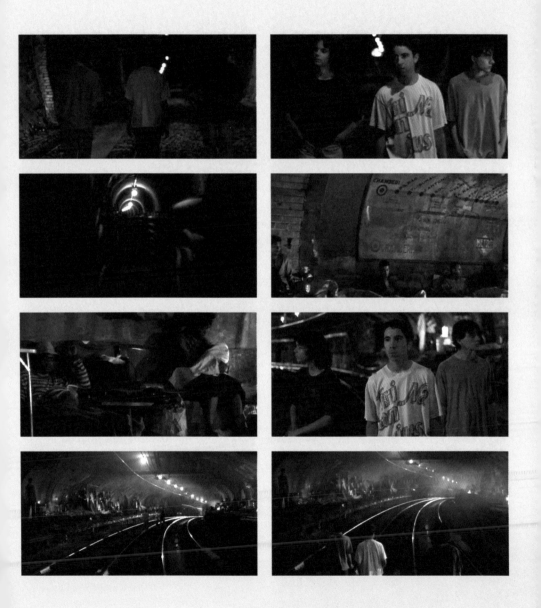

Images © 1997 Elías Querejeta Producciones Cinematográficas; MGN Filmes; Sociedad General de Televisión (Sogetel)

MADRID

Unexpected Dream Factory

Text by
HELIO SAN
MIGUEL

MADRID'S LOVE AFFAIR with cinema has been a long and fruitful one. Spain's most important directors have shot some of their most vibrant movies in the streets of Madrid and its production facilities. Madrid is also a great exhibition centre. The Doré theatre, which today houses the Filmoteca Nacional, was built in 1912. Construction of the grand art-deco theatres, many in Gran Vía and some still in operation, followed suit reaching forty venues by the late 1930s. Today Madrid has an exceptional collection of art-house multiplexes that offer one of the most extensive and diverse selections of international films. Even the streets of Madrid Sur, a neighbourhood created in the 1990s, were named after classical movies so one can walk down Mogambo street, turn right at Tristana, cross Fantasia, and keep walking until Novecento or Sabrina.

Despite this, two of the most important features of Madrid's cinema remain largely unknown, even to Spaniards: its role as a

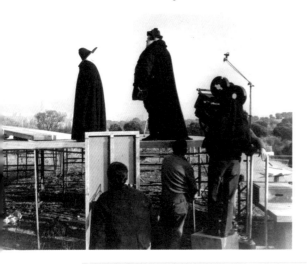

centre of international productions and the considerable size and impact of its film industry. But it wasn't an easy journey. Madrid's filmmaking history started in 1896 when Jean Alexander Promio, a Lumières operator, shot bullfighting shows, Puerta del Sol, Puerta de Toledo, and the Royal Palace. Newsreels production soon developed including famous ones like the wedding of Alfonso XIII in 1906, where the attempt to kill the king in Mayor Street was filmed, and the assassination and burial of Canalejas in 1912. Pioneer Benito Perojo created Patria Films and Madrid's production grew slowly until the 1920s, when *La verbena de la Paloma* (José Buchs, 1921) marked a turning point, due to its production values and success. Madrid, with already three studios, Atlántida, Madrid Films, and Films Española, surpassed Barcelona. In 1928, 44 of the 58 Spanish features were made in Madrid. In 1929, ABC newspaper called Madrid 'Spain's Hollywood'. Spain's first *talkie*, *El misterio de la Puerta del Sol*, was made there. Other important films like Florián Rey's *Agustina de Aragón and La aldea maldita/The Cursed Village*, recreated their settings in Madrid's burgeoning studios.

Due to costly sound investments, production fell to 6 movies in 1932, and Hollywood films made in Spanish filled that gap. However, that year CEA (Compañía Española y Americana) studios opened and others (ECESA, Ballesteros, Chamartín, Iberia Films, and Filmófono, where Buñuel worked) soon followed. Production grew again: 17 films in 1933, 21 in 1934, 36 in 1935, and 28 in 1936, the year the Civil War started. Film production almost totally halted and Franco's victory provoked a massive exile of artists and intellectuals. But it slowly resumed. Sevilla

Films was built in 1941, and CIFESA, a company founded in the 1930s and operating in the Hollywood studios model, dominated the film landscape with government supported grandiose recreations of Spain's imperial past (*Locura de amor [Love Madness]*, *Alba de América*, *Don Quijote*, etc.). Juan de Orduña and Rafael Gil were the main directors, aided by Sigfrido Burmann, the talented set decorator of over 100 movies.

A reaction materialized in the 1950s due to the impact of Neorealism and the creation in 1947 of the Instituto de Investigaciones y Experiencias Cinematográficas, that later became the Escuela Oficial de Cine. But another trend also developed: Madrid's streets, surrounding landscapes, and reputedly beautiful light, along with its production companies and facilities, attracted foreign filmmakers and served to recreate numerous unsuspected locations, like Imperial Rome, Shakespearian England, Tsarist Russia, *spaghetti westerns*, and 19th century China. Rex Ingram had shot *Mare Nostrum* in Madrid in 1926, and Mexican Fernando de Fuentes directed *Jalisco canta en Sevilla [Jalisco Sings in Seville]* in Chamartín studios in 1949, launching co-productions with Latin America. In the 1950s Welles did parts of *Mr. Arkadin* in Sevilla Films; Robert Rossen made *Alexander the Great*; Michael Anderson, *Around the World in Eighty Days*; Stanley Kramer, *The Pride and the Passion*; King Vidor, *Solomon and Sheba*; and Kubrick, *Spartacus*. In the 1960s, Samuel Bronston bought and renamed Chamartín studios and made it, along with Madrid's landscapes, the set for monumental productions such as *King of Kings*, *El Cid*, *55 Days in Peking*, *The Fallen of the Roman Empire*, and *Circus World*. Casa de Campo park was used in Leone's *A Fistful of Dollars* and the battle scenes in Welles' *Chimes at Midnight*. Also among others, Andrew Marton shot *The Thin Red Line*; Negulesco made *The Pleasure Seekers*; Richard Lester, *A Funny Thing Happened on the Way to the Forum*; Robert Siodmack, *Custer in the West* in Sevilla Films; and David Lean used CEA studios for *Dr. Zhivago*, where Madrid's trams became Moscow's. After the 1960s international productions slowed down, but did not stop. From Wim Wenders' *The Scarlet Letter*, to Jim Jarmusch's *The Limits of Control*, through *Moulin Rouge!*, *Quantum of Solace*, *The Bourne Ultimatum*, Jackie Chan's *Operation Condor*, and Milos Forman's *Goya's Ghosts*, more than 200 foreign films have been shot totally or partially in Madrid's studios, streets, and surrounding region.

At the same time, with the 1970s' economic expansion and democratization, the film industry grew so much that over half of all fiction features shot in Madrid's history have been made since. In the 1980s TVE (Spain's public television), bought the Bronston studios and renamed it *Luis Buñuel*, and in the 1990s it opened the huge (over a million square meters) and ambitious *Ciudad de la Imagen*, whose streets, named after famous directors, house soundstages, post-production facilities and a Film School. Also, Madrid, along with Berlin, Paris and Rome, established the association Capital Regions for Cinema in 2005 to promote co-production, distribution and support for audiovisual projects. In addition, Madrid has a growing impact on the cinema made beyond its borders; as Spain's capital, government subsidies for film production are awarded there, and the many production companies headquartered in the city finance both domestic movies and, increasingly, co-productions, especially with Latin America.

As a result, today Spain is one of the top seven film-producing countries in the world, exceeding 100 features yearly, and reaching 201 in 2010. Over half of Spain's features and 70% of its audiovisual industry are produced in Madrid.

In 1925, when visionary filmmaker Manuel Noriega made the futuristic film *Madrid en el año 2000*, he optimistically envisioned Madrid as a seaport, but could not imagine it as the major film location, production and exhibition centre that it is today. A long and prolific journey, indeed. ✤

Madrid's streets, surrounding landscapes, and reputedly beautiful light, along with its production companies and facilities, attracted foreign filmmakers and served to recreate numerous unsuspected locations.

MADRID

Casa De Campo

Central Madrid

37
34
36
38

LOCATIONS
SCENES 33-38

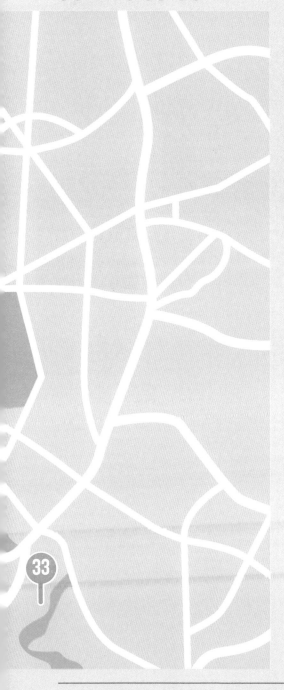

LUCKY STAR/LA BUENA ESTRELLA (1997)

Mercamadrid, 23 (Merca Carne)

IN ONE OF THE MOST IMPRESSIVE opening sequences in Spanish cinema of the 1990s, Rafael (Antonio Resines), a butcher, witnesses the attack on Marina (Maribel Verdú), a one-eyed pregnant woman, close to Mercamadrid (the biggest wholesale supplies and food market in Madrid) in a cold, dirty and lonely underpass on the periphery. Rafael frightens the attacker with his large slaughterman's knife, takes Marina home and becomes committed to caring for the unborn child. Later, he will start falling in love with her. But everything gets complicated when the real father, Daniel (Jordi Mollà), arrives home after being imprisoned. The scene is even more stunning if we compare the contrast of the cold blue light with the bright red of the previous scene – the opening credits, in the slaughterhouse, where Rafael has come to collect meat. The actual location is bleak, despite being relatively close to the city and the light accentuates the threatening aspect of the situation, one that corresponds with the duel between two men fighting over a woman. Although from the beginning, we know the winner will be Rafael, who, in the face of the nervous gesticulations of the other, shows just the right and necessary gestures. Although we do not know yet that the attacker is Daniel, from this moment the triangle on which the movie is based is built. Although Raphael had accidentally castrated himself with his butcher's knife as a young man, he is still able to use a knife against the blind violence of Daniel against Marina. He will also be there to name the baby and even to put aside his pride to satisfy the wishes of Marina. **↝Lorenzo J Torres Hortelano**

(Photos © Lorenzo Torres)

Directed by Ricardo Franco
Scene description: Rafael saves La Tuerta
Timecode for scene: 0:02:57 – 0:05:10

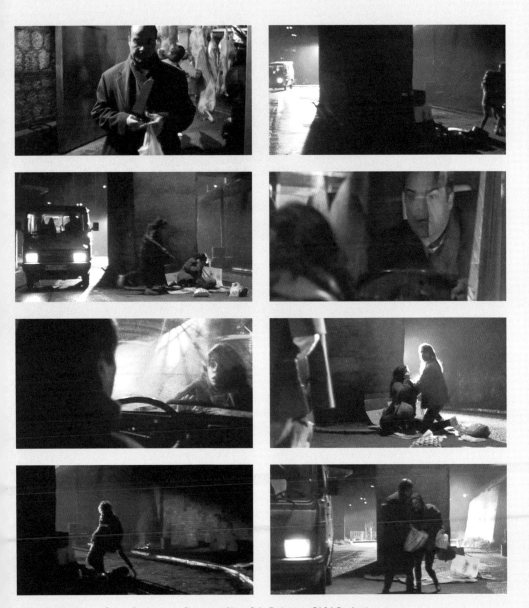

Images © 1997 Enrique Cerezo Producciones Cinematográficas S.A.; Eurimages; GA&A Productions

OPEN YOUR EYES/ABRE LOS OJOS (1997)

LOCATION *Gran Vía (looking towards Plaza de España) and streets around (barrio de Chueca and Malasaña)*

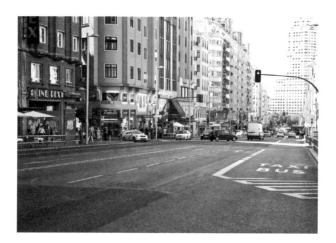

WHEN CAMERON CROWE and his team decided to remake, with Tom Cruise, this Spanish film, surely this was one of the sequences that most impressed to them – Gran Vía empty. It was shot in the middle of August, at dawn, without computer assistance. Interestingly, the story in the remake, *Vanilla Sky* (2001), was moved to New York, which reminds us that Gran Vía is the closest thing to that most cinematographic New York image – Fifth Avenue. César (Eduardo Noriega), tells his story to a psychiatrist through a series of flashbacks. It is a mixture of psychological thriller and science fiction, but it tries to get us into the mind of a 20-year-old man, wealthy, handsome and a successful bachelor, which will, at the same time, make him take the wrong path. He and his ex-girlfriend Nuria (Nawja Nimri) play out a suicide pact in the car; however, César survives but his face is disfigured. After this, the girl he is really in love with, Sofía (Penélope Cruz, who plays the same role in *Vanilla Sky*), will break up with him. This sequence, located at the start of the film shows what looks like the start of a normal day for César, but it turns into a nightmare as he goes through the absolutely empty streets of Madrid until he gets out of the car and runs, panicking, across Gran Vía. Until this particular scene, the Gran Vía had never been filmed quite like this – and has never been since. We can name the pictorial influence of the *Gran Vía* series of paintings by Antonio López, done between 1975 and 1980 in the early mornings of five Madrid summers, and which, with *Open Your Eyes*, shares the unreal appearance of the empty Gran Vía. **➻Lorenzo J Torres Hortelano**

(Photos © Eduardo Hernández)

Directed by *Alejandro Amenábar*
Scene description: *César runs alone in Gran Vía*
Timecode for scene: *0:01:35 – 0:03:38*

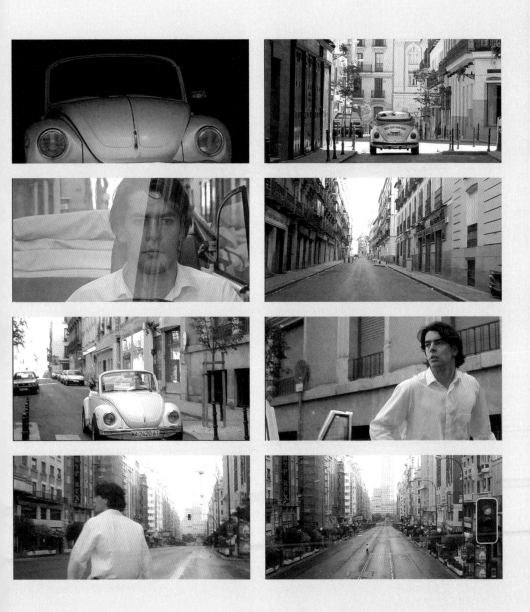

Images © 1997 Canal+ España; Las Producciones del Escorpión S.L.; Les Films Alain Sarde

SECOND SKIN/SEGUNDA PIEL (1999)

LOCATION *Ristorante San Carlo in Calle Barquillo*

SECOND SKIN IS A STYLISH FILM made of small gestures and the gazes of a talented and restrained cast revealing the troubled and confused mind of the characters. They are supported by Gerardo Vera's deft and meaningful use of colour. Madrid is the backdrop of an oppressive and increasingly untenable situation for Alberto, an engineer and the anguished leading character. The only place where he is happy is in the apartment of his lover Diego, which is painted in warm, red tones. Even Diego's car is red. In all the other places where Alberto spends his life, other tones suggesting coldness, boredom, and negativity prevail. He lives with his wife and child in an affluent suburb, which is mostly blue, purple and dark green. The hospital where Diego works is dominated by green tones, from the clothes to the operating room. Alberto's workplace, which he hates, is mostly grey, like his car. The film subtly dwells on these meaningful patterns in almost every scene. After his wife Elena has discovered the shocking truth about her husband, they still make an effort to give it one more chance. They go to dinner in a restaurant dominated by a warm yellow light. He has on a red shirt; she is wearing a black dress with splashes of red flowers. Alberto first proposes that they move out of Madrid, but soon the conversation turns sour. Agitated, he runs out of the restaurant and she follows him. Alberto is crying desperately in the street and asks her for help. Elena hugs him tenderly; again it seems like there might be a chance for reconciliation. However, the blue tones of the façade of the restaurant and a prominent blue street light serve as a premonition. **↦ Helio San Miguel**

(Photos © Miriam Montero)

Directed by Gerardo Vera
Scene description: Alberto and his wife have dinner trying to salvage their marriage
Timecode for scene: 1:07:17 – 1:11:00

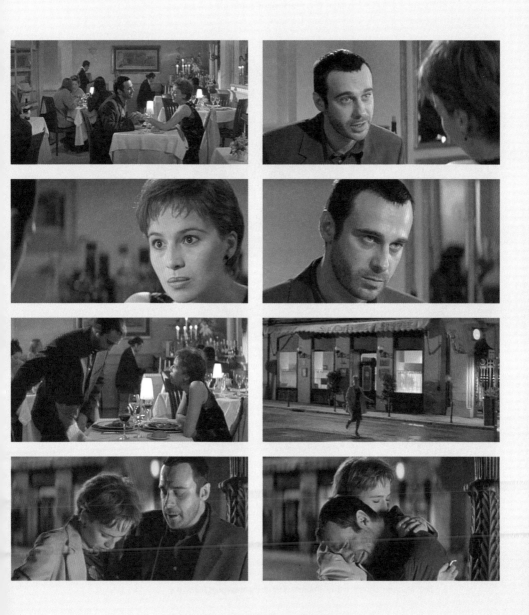

Images © 1999 Antena 3 Televisión; Loafilms; Vía Digital

HEART OF THE WARRIOR/
EL CORAZÓN DEL GUERRERO (2000)

LOCATION *Congreso de los Diputados*
(Plaza de las Cortes, Carrera de San Jerónimo, 39)

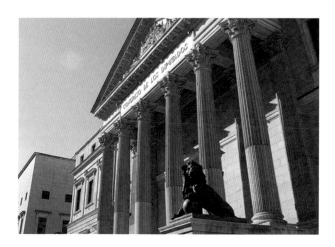

THIS WAS THE FIRST FILM by Daniel Monzón, responsible for one of the great successes of recent Spanish cinema in 2009, *Celda 211/Cell 211*. *Heart of the Warrior* is a film without any claim other than as entertainment, but is a very decent production, borrowing genre codes from teen comedy and science fiction, unprecedented in Spanish cinema, with the addition of RPG (Role Playing Games) and comic aesthetics. The city of Madrid is a perfect setting for such games using the terraces of hotels on the Gran Vía and the nooks and crannies of subway tunnels. But, in addition to pure entertainment, comedy, as known by the great masters like Charlie Chaplin or Luis García Berlanga, is a perfect genre for subversive criticism. It is here where we must place the importance of this sequence from the heart of the film. Ramón (Fernando Ramallo), a teenager, along with some colleagues, likes role-playing, to the point where he begins to mix fantasy with reality. In the fantasy world he is the hero Belder (Joel Joan), who is accompanied by the sensual and courageous Sonja (Neus Asensi), a prostitute named Sonia in the real world. Ramón/Belder receives a curse for stealing a treasure and goes to Congress, where he believes he will find the antidote. The monochromatic honourable members are not sympathetically portrayed. They are the enemy; therefore, Ramón throws his knife at the speaker. Finally, he flees through the halls of Congress. The Congress building, which dates from 1850, is an idiosyncratic way into the popular spirit of Madrid. Despite the social and political importance of this place, it is easily accessible at street level; and has become just another place on the way to other points of touristic importance, like Puerta del Sol or Museo del Prado. **→Lorenzo J Torres Hortelano**

(Photos © Alicia G. González)

Directed by Daniel Monzón
Scene description: Belder and Sonja storm the Congress Building
Timecode for scene: 0:43:55 – 0:48:41

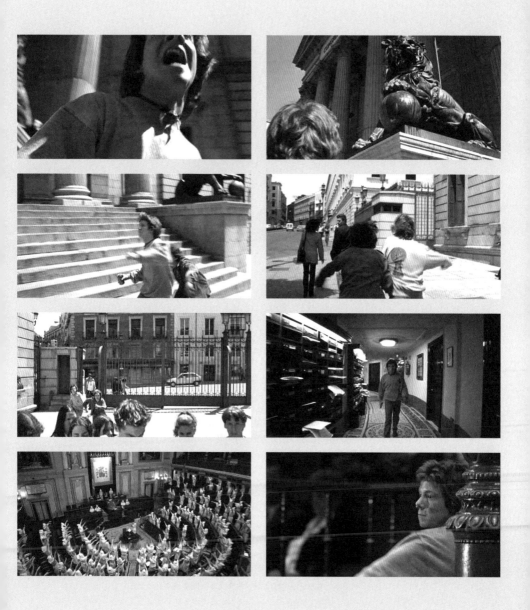

Images © 2000 Creativos Asociados de Radio y Televisión (CARTEL); Televisión Española (TVE); Tornasol Films

SEX AND LUCÍA/LUCÍA Y EL SEXO (2000)

Plaza de las Comendadoras, 1

THIS WAS THE CINEMA AUDIENCE'S first glimpse of Paz Vega, who would later become a huge star. Lucía's (Paz Vega) strip-tease in front of Lorenzo (Tristán Ulloa) has now become an iconic scene in Spanish cinema. In fact *Sex and Lucía* is full of scenes related to sex or eroticims: Lorenzo's erect penis cherised by Lucía; Belén (Elena Anaya, whom Médem used in another even more sexually explicit film, *Room in Rome*, 2010) masturbating while watching a porno movie; or the beach scene where Carlos (Daniel Freire) gets his penis smeared with clay by Lucía. In this sense, the origin of the whole story is a night love scene by the sea between Elena (Nawja Nimri) and Lorenzo in the light of the full moon. Lucía, Lorenzo, Elena, Belén and Carlos all intersect in a polyhedral story told in flashbacks, in melodramatic style but with a very modern aesthetic, perhaps due to being the first European film shot entirely in a digital format. What we see in this sequence could be the heart of the tale, as Lorenzo writes to Elena, trying to relieve the pain of the death of her daughter: 'la mayor ventaja del cuento' ('the greatest advantage of the tale') is that, when it ends, it starts over again at its centre with the possibility of changing its course. This centre could be the Plaza de las Comendadoras ('Commanders') at the very end of the film: Elena photographs her daughter (in front of the popular Café Moderno) while Lucía and Lorenzo live happily together at the top of the building. As with many other places in Madrid, this central square is not really beautiful, but it is special and intimate, and it is the meeting place for modern or fashionable people; a haven of peace in the busy routine of the city. **⇢Lorenzo J Torres Hortelano**

(Photos © Lara Pérez)

Directed by Julio Médem
Scene description: The story begins again, at its center...
Timecode for scene: 1:59:07 – 2:02:33

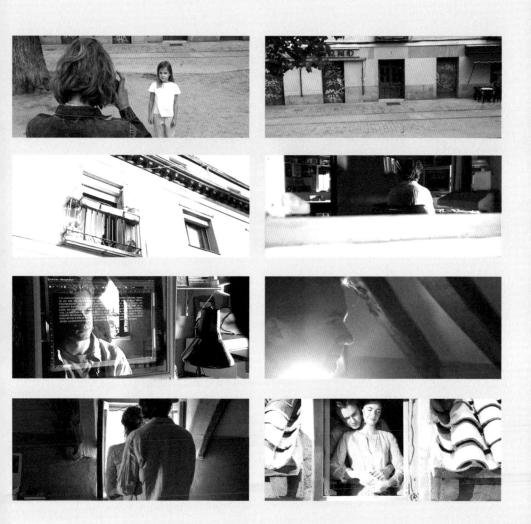

Images © 2000 Alicia Produce; Canal+ España; Sociedad General de Cine (SOGECINE) S.A.

TALK TO HER/HABLE CON ELLA (2002)

Calle Prado, 2, and Calle Echegaray (Barrio de las Letras)

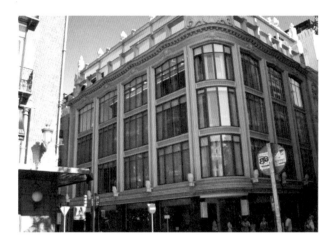

TOWARD THE MIDDLE of this film, Almodóvar takes time to insert one of the several flashbacks that populate the narrative; on this occasion, going back four years. It explains how Benigno (Javier Cámara) met Alicia (Leonor Watling), before she fell into a coma in the hospital where he works as a nurse. Somehow, we go to the origin of the story to try and understand the subsequent events; although this flashback is not an explanatory sequence, it shows the dreamy power of the desiring gaze. Benigno, at that time, lived cloistered with his mother, of whom he took care. He reveals clear voyeuristic tendencies: from his window he watches, fascinated by the flexible body of Alicia, who practices dance at the ballet academy oppposite – now, since 2006, transformed into the Room Mate Alicia Hotel, in honour of Almodóvar's character. One day, while spying on her, she drops her wallet on the street; Benigno goes down, picks it up and runs after her to return it. She is overjoyed at his kindness and he takes advantage of this by accompanying her home. Benigno's intense look of desire seems, in this dreamlike scene, neither sick nor obsessed but, simply, of someone in love. When he is later accused of raping Alicia in the hospital (having made her pregnant), this previous gaze certainly resounds with ambiguity in the mind of the viewer – to the point of wondering whether it was indeed a rape. Perhaps, therefore, it is a gaze that denotes the infinite loneliness of the characters in *Talk to Her*. ➤ **Lorenzo J. Torres Hortelano**

(Photos © Miriam Montero)

Directed by Pedro Almodóvar
Scene description: Benigno meets Alicia after her ballet class
Timecode for scene: 0:42:27 – 0:46:05

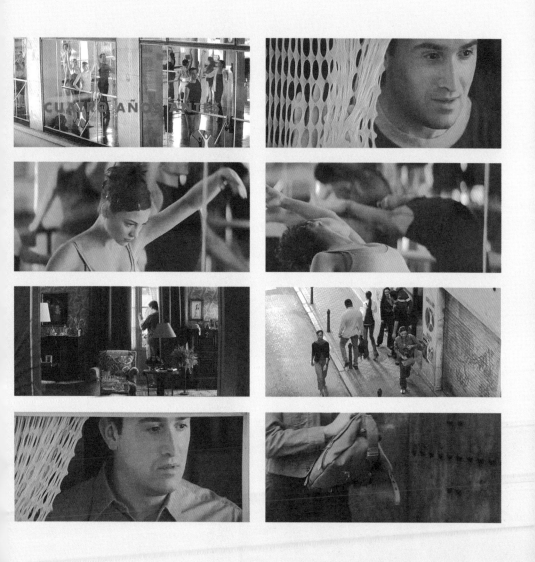

Images © 2002 El Deseo S.A.; Antena 3 Televisión; Good Machine

BEYOND CLICHÉ

Text by
JOHN D
SANDERSON

Madrid in Twenty-first Century American Thrillers

THE POINT OF VIEW established by the predominant story-teller assumes that a series of features ascribed to a specific nationality will be de-codified by the target audience following a process that implies identification, differentiation and, very often, devaluation. In Classical Hollywood films, the master narrative traditionally managed to economize plot and/or character development by the use of visual elements, which conveyed a wide variety of semantic, loads easily, recognizable by the average spectator. As far as Madrid is concerned, in order to present the exploits of outsiders visiting the city, the 1950s' American film industry recreated its streets in a wide variety of locations, such as the 20th Century Fox studios in California (*The Snows of Kilimanjaro*, Henry King, 1952) or the Cinecittà studios in Rome (*The Barefoot Contessa*, Joseph L Mankiewicz, 1954). This was probably done to avoid the interference of Generalísimo Franco's strict censorship. In any case, the features were usually the same: squalor and dirt, flamenco music and dance, bullfighting, hot-blooded

sexuality, which contrasted with strong religious piety and references to the Spanish Civil War. This was done so that the audience could tell the film apart from Mexico.

It was as late as 1987 when an American film, Mary Lambert's unclassifiable *Siesta*, first used the actual city of Madrid as the main contemporary setting of the film plot. But clichés still remained. The movie begins with Claire (Ellen Barkin), the American outsider, waking up ruffled at the foot of an airport runway with bloodstains all over her. She gets a lift from a lascivious Spanish taxi driver (Alexei Sayle), who takes her to Madrid, where we are shown some landmark locations. The first building she expectedly comes across is a church, San Francisco el Grande. Old women wearing black veils over their heads walk past her crossing themselves, and she almost trips over a beggar on the pavement of the street that leads to the church.

Besides the taxi driver, who will eventually rape her, the other main Spanish characters are Augustine (Gabriel Byrne struggling to produce a foreign accent), an old crush of Claire's whom she has flown all the way from California to track down, and his newly-wed wife María (Isabella Rossellini), who is clearly a national: in a fit of jealousy she will stab her rival to death, as we would expect from a hot-blooded Spanish female. We also have Conchita, a model, whose part is puzzlingly played by Grace Jones; she does wear a typical flamenco convex comb on her head permanently, though. When Claire is taken to Conchita's flat she manages to escape by jumping out of a window onto the roof of a tourist bus, losing consciousness. When she comes to, it has driven through Madrid up to the Plaza de las Ventas, the local bullring (the most famous in the world), and yet

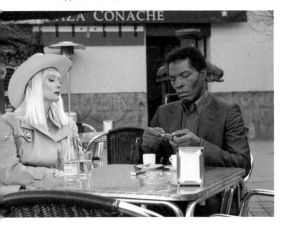

in sharp contrast with the Keystone-cop attitude that had been displayed in *Siesta*.

Then we have *Deception* (Marcel Langenegger, 2008), where all the devious sex takes place in Manhattan, as well as a plot hatched by conman Jamie Getz/Wyatt Bose (Hugh Jackman) to force accountant Jonathan McQuarry to transfer 20 million dollars of black money from the company he works for to a bank in Madrid. He agrees because he fears for the life of an anonymous woman he met through a sex club, whom Bose has taken with him to the Spanish city because she had actually played an essential part in McQuarry's deception, though now she has second thoughts. The last 27 minutes of the film are located in Madrid, giving us the opportunity to visit the hotel Palace, the calle de Alcalá and, in the final climatic panoramic shot, the Plaza Mayor, the romantic environment where Jonathan and the anonymous woman will realize that they have fallen in love.

But it is Jim Jarmusch who perfectly collages traditional and avant-garde Madrid in the first 42 minutes of *The Limits of Control* (2009). The morning espressos our also-anonymous hero drinks in the ancient Plaza de San Ildefonso are put together with the cocktails he sips in the cool nightlife joints he goes to; he regularly visits the Centro de Arte Reina Sofía, a remarkable post modern museum, not the church which gives its name to the square. And the iconic sight of Madrid in this production is, in any case, the building where he is staying: the striking Torres Blancas in the Avenida de América, an example of modern architecture that would have never been chosen as a location in a twentieth-century foreign movie. Curiously enough, it was built in 1961, so it took almost fifty years to squeeze its way into an American film.

another location that fits in perfectly with our expectations. And flamenco, of course, is everywhere. Remarkably, the buskers who sing at the terrace of the café in the calle del Conde are reputed Spanish performers Lole y Manuel, while Claire walks the tightrope and her friend Nancy (Jodie Foster) dances flamenco and collects money from the café's customers. Mary Lambert's following film was Pet Sematary (1989). Three years later she directed *Pet Sematary II*.

Fortunately, twenty-first-century American thrillers present a very different picture of the city. In three consecutive years they have put Madrid on the map as a modern urban enclosure comparable to any other major capital. It all began with Jason Bourne (Matt Damon), who, during his world tour, visited Madrid in his third installment, *The Bourne Ultimatum* (Paul Greengrass, 2007). Here he locates a CIA undercover office in a building in the traditional centre of Madrid, calle Virgen del Peligro next to Gran Vía, where the advanced technological gadgets blend with the ancient furniture of the old flat in which Bourne is trying to put his puzzling past together. And when the CIA agents turn up to kill him, the Spanish police will deal with them very efficiently,

In Classical Hollywood films, the master narrative traditionally managed to economise plot and/or character development by the use of visual elements.

And, most important of all, if you watch these three thrillers back to back, there is not a single second of flamenco or bullrings. The predominant master narrative has definitely changed its depiction of the city, with those ancient cultural stereotypes no longer present. Madrid has finally entered the twenty-first century for international cinematic eyes.✠

MADRID

LOCATIONS MAP

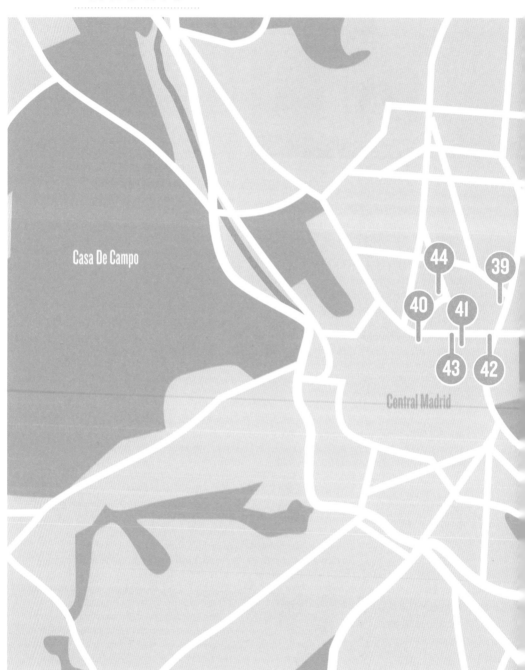

Casa De Campo

44

39

40

41

43 42

Central Madrid

LOCATIONS
SCENES 39-44

NOVEMBER/NOVIEMBRE (2003)

LOCATION *Paseo de Recoletos, Plaza de Cibeles and Gran Vía*

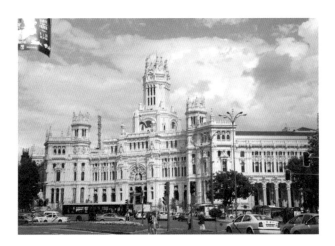

THIS FILM IS CONSTRUCTED like a mockumentary in which older characters tell us, in the year 2040, about an intense moment in their lives from their youth at the beginning of the 21st century: the formation of a theatre group called *November*. In this scene we see Alfredo (Oscar Jaenada), a young idealist who came to Madrid from a village in Murcia to study acting. He manages to gather a group of partners with whom he forms *November*. The philosophy of this group is to bring theatre to the streets to de-glamorize war and alienation and charge nothing, because, as Alfredo says 'el arte, cuando hay dinero por medio, se pudre' ('art, when there is money involved, rots'). The opening credit sequence already shows that mix between reality and fiction, as the images of Alfredo are interspersed with the credits. The viewer sees Alfredo's face, which has a mixture of fascination and respect for the scene he wants to be part of but which, with a utopian zeal, he wants to change. This ambivalence, reinforced by the music leitmotif – a beautiful and sad monotone melody – is reflected in the threat that the cars pose to his fragile bike. This underlying threat prepares the viewer for what will happen in the end when he becomes a puppet in the stunning final scene at the Teatro Real. The Cibeles-Recoletos-Gran Vía artery is one of the must-see areas for any tourist who comes to Madrid. But the fact that Alfredo cycles through the cars, leaving Cibeles (Cybele, earth fertility goddess) behind, and the fact that he visually blocks the entrance of the Bank of Spain with his body, informs the audience that his is not going to be the life of a tourist. **⇢Lorenzo J Torres Hortelano**

(Photos © Alicia G. González)

Directed by Achero Mañas
Scene description: *Alfredo is amazed by the big city*
Timecode for scene: *0:00:00 – 0:01:51*

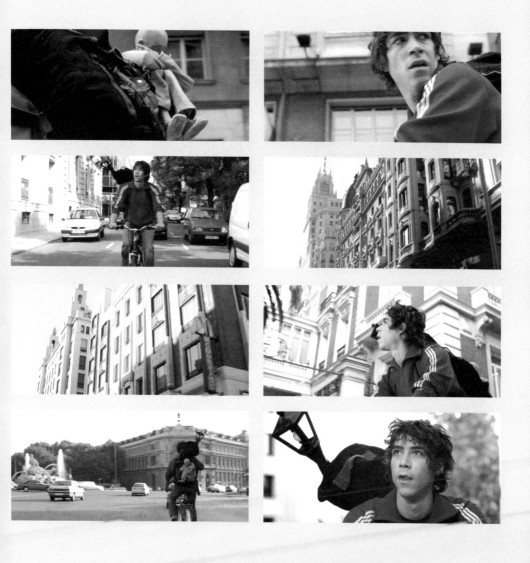

Images © 2003 Alta Films; Tesela Producciones Cinematográficas

CAMARÓN (2005)

Torres Bermejas, calle Mesonero Romanos, 11

TORRES BERMEJAS is a *tablao* (a place for dinner and drinks while listening to and watching the art of flamenco) very close to the Plaza Mayor, and is advertised on its website as 'the best in the world'. Two of the best flamenco artists of all time started playing there together in 1969, as shown in this sequence from this biopic directed by Jaime Chávarri (who had made other musicals). The film shows the whole life of the great singer, Jorge Monge Cruz (Oscar Jaenada), known as *Camarón de la Isla* (for the island of San Fernando, Cádiz, where he was born). After living in poverty for a while in the capital, the Promised Land for all self-respecting flamenco artists, Camarón began a lifelong collaboration with Paco de Lucía (Raúl Rocamora). Their music would change the flamenco world, bringing it to wider audiences – as can be deduced from the public reaction in the second half of the sequence. Cinematically, for this 'nuclear' event, Chávarri opts for a classic stage in the first half of the sequence, and low-key lighting. At the rehearsal, only Paco de Lucía's father (Manolo Caro) and his brother, Ramón de Algeciras, are there but, despite the sparse audience, you can see Camaron's discomfort, in general, at being in public. They rehearse 'Barrio de Santa María', the traditional *alegría* ('joy') – a music style within flamenco – that starts with the famous 'Tirititrao, trao, trao...'. This song, with its mixture of joy and sadness portrays the master perfectly. The classical staging of this moment of the sequence is logical if we look at the exact period of flamenco orthodoxy of both artists. But, in the second half, the director sound-bridges the song, and the scene becomes more dynamic, with bright lighting, which more accurately conveys the 'revolution' of these masters' performance. ➜**Lorenzo J Torres Hortelano**

(Photos © Miriam Montero)

Directed by Jaime Chávarri
Scene description: Camarón and Paco de Lucia start their realationship
Timecode for scene: 0:32:55 – 0:36:19

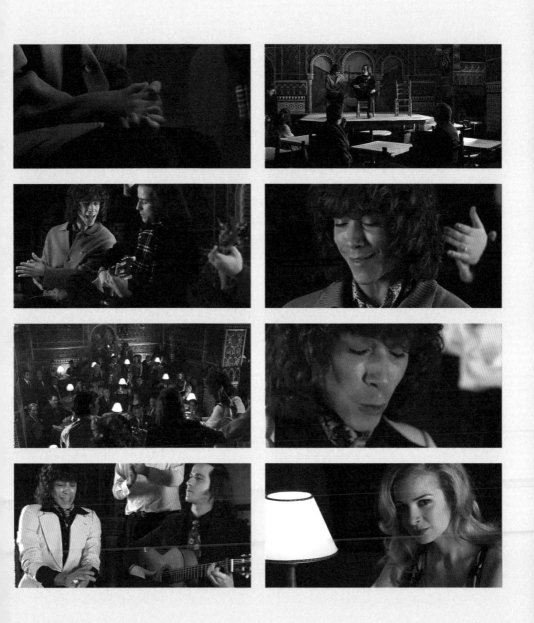

Images © 2005 Filmanova; Monoria Films; Televisión Española (TVE)

THE BOURNE ULTIMATUM (2007)

Calle Virgen de los Peligros

NEAL DANIELS (Colin Stinton), station chief of the CIA in Madrid, has been tipped off by a journalist from *The Guardian* about 'Blackbriar', a secret operation programme which has absorbed Treadstone, the organization that turned David Webb into professional killer Jason Bourne (Matt Damon). When the journalist is murdered, Daniels flees Madrid, but Bourne has already found out that the cover organization for the CIA is Rufus and Sewell Global Markets and Investment, and the address is 334 calle del Norte, 8, 28014 Madrid. This should be highly suspicious, though, since Spanish addresses do not feature a number before the name of the street, only after it. When Bourne gets to Madrid, he actually walks down calle de los Jardines into calle Virgen de los Peligros (Virgin of the Hazard Street in English), a traditional commercial street in the city centre which joins two of its main arteries, Gran Vía and calle de Alcalá. He crosses the street and manages to open the huge wooden door of what would be number ten, not number eight or calle Del Norte either. He walks up two flights of stairs (he does not trust the ancient elevator), breaks into Daniels office and finds documents and photographs which trigger off diverse flash-backs about his origin. The CIA headquarters in Virginia find out that he is there and send two hit-men, which are conveniently disposed of. Then Nicolette Parsons (Julia Stiles), a former Treadstone employee re-emerging from *The Bourne Supremacy* (2004), turns up by chance, but now she is on his side and will help him escape with her car. A supporting seven-man-gang have been contacted from Virginia, but Bourne has rung the Spanish police, who will efficiently arrest the CIA thugs on arrival, causing quite a stir at calle Virgen de los Peligros, while Bourne and Nicolette drive away. **➻John D Sanderson**

(Photos © Alicia G. González)

Directed by Paul Greengrass
Scene description: Action-packed city centre
Timecode for scene: 0:33:40 – 0:41:37

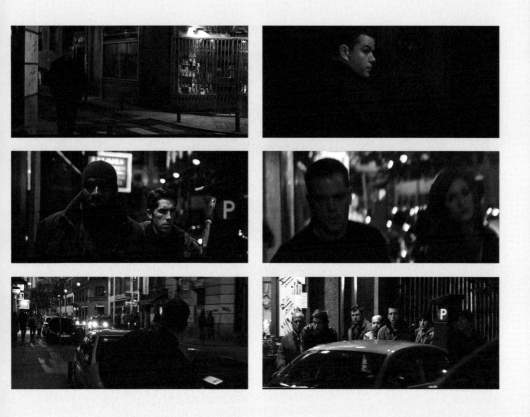

Images © 2007 Universal Pictures; Motion Picture BETA produktionsgesellschaft

DECEPTION (2008)

Instituto Cervantes, Calle de Alcalá, 49

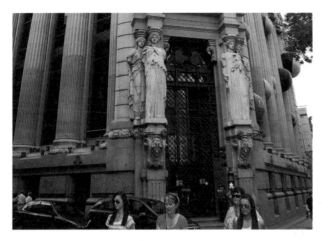

WYATT BOSE (Hugh Jackman) has flown to Madrid with his blonde girlfriend (Michelle Williams) to collect the 20 million dollars of black money he coerced the now-presumably dead accountant Jonathan McQuarry (Ewan McGregor) to transfer to the Banco Nacional de San Sebastián. The fictional bank is located in calle de Alcalá, currently the headquarters of the Instituto Cervantes, a public organization that promotes Spanish culture and language worldwide, with 45 international branches. Popularly known as the Caryatides building for the four figures at its main entrance, it was formerly the main office of the Banco Central, so it must have been relatively easy to transform into a bank again for the film. When Bose and the blonde woman enter the building, designed in 1918, she waits in the main hall while he walks into an office pretending to be McQuarry. If the security measures at the Banco Nacional are of a similar standard to their fluency in English (we can see a computer screen full of spelling mistakes), we can understand how easily Bose gets through. But McQuarry had played a trick on Bose: he needs a co-signature: his own. He angrily storms out of the office and sees that the blonde woman is no longer there. He leaves the building, and comes across McQuarry himself. While they talk to each other, we can admire in the background the Metropolis building, topped by the statue of the Winged Victory. Criss cross. They need to impersonate each other to draw the money out of the bank. Ten million dollars each in two briefcases, McQuarry suggests. Bose agrees. They go into the bank together now, and we have the opportunity to look around the impressive Caryatides building again. When they finally leave with their money, McQuarry confesses it is really the blonde woman he longs for. ⦁➤ *John D Sanderson*

(Photos © Alicia G. González)

Directed by Marcel Langenegger
Scene description: Black money at Banco Central (nowadays Instituto Cervantes)
Timecode for scene: 1:22:11 – 1:28:55

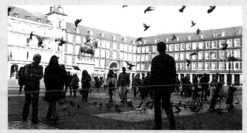

Images © 2008 Seed Productions; Rifkin-Eberts; Kanzaman

BROKEN EMBRACES/LOS ABRAZOS ROTOS (2009)

Museo Chicote (Gran Vía, 12)

MATEO (LLUÍS HOMAR), a film director, and Lena (Penélope Cruz), his lead actress, make a secret trip to Lanzarote in order to get away from her abusive husband, the entrepreneur Ernesto Martel (José Luis Gómez). Ernesto also produced the film that the two secret lovers made together in Madrid, Girls and Cases. The trip will have fatal consequences: because of a car accident there, Lena dies and Mateo goes blind. Back in Madrid, even though there are up to four medical locations in this film where so many characters fall ill and have accidents (Clínica Quirón and Hospital Manzanares are the most easily recognizable), we are going to focus on the scene at the Bar Museo Chicote. Years later, when blind Mateo meets his production assistant, Judit (Blanca Portillo) and her son Diego (Tamar Novas), she confesses about what had happened to the film released 14 years earlier while Mateo and Lena were in Lanzarote. Martel had taken his revenge on them by having Judit and a colleague choose the worst takes and perform the worst possible editing so that the film premiere would be a disaster. It was her revenge as well: she resented Mateo leaving with Lena without telling her. The Bar Perico Chicote was opened in 1931 by a barman of the same name, and has been an iconic nightlife meeting place ever since. People from all walks of life: actors, writers, bullfighters, politicians, members of royalty, etc, had their last drink at Chicote, and it was also a popular joint for foreign film crews, especially while Samuel Bronston's film studios were productive (1958–1964): Ava Gardner, Sophia Loren and many others had their photograph taken there. Chicote even played cameo roles himself, as in *All is Possible in Granada* (1954), starring Merle Oberon. ↝*John D Sanderson*

(Photos © Miriam Montero)

Directed by Pedro Almodóvar
Scene description: Judit's confession fourteen years later
Timecode for scene: 1:36:51 – 1:42:17

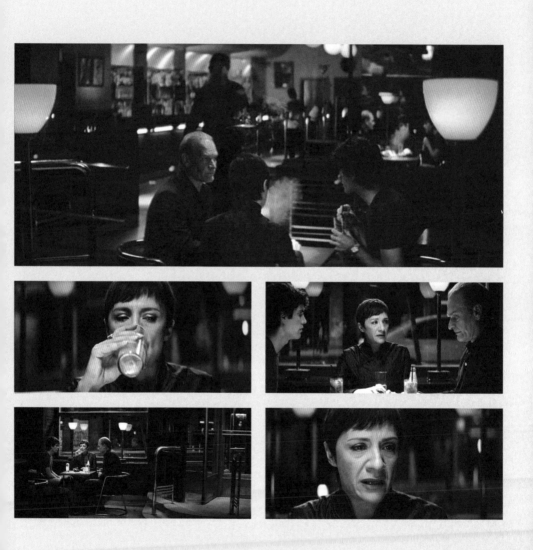

Images © 2009 Universal Pictures International (UPI); Canal+ España; El Deseo S.A.

THE LIMITS OF CONTROL (2009)

LOCATION *Plaza de San Ildefonso*

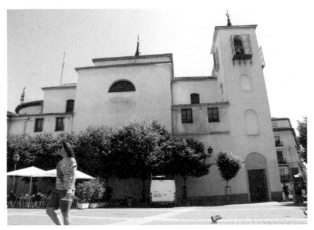

AN UNNAMED main character (Isaac De Bankolé) follows a daily routine, which involves going to the Plaza de San Ildefonso, the Barrio of Malasaña, every morning and back to his home of La Movida. Nowadays it is a more relaxed place, at least during the daytime, after its neighbours put pressure on the local authorities to eradicate the drug problem that made the area hit rock bottom in the early nineties. Now you can walk the beautiful narrow streets safely, sit at cafés in the squares, look around and do nothing. This is what our character does; he always orders an espresso in two separate cups at the café. The first time he is on his own and watches people stroll by. The second time he goes to the cafe a man carrying a violin sits next to him. The violinist asks him the customary, 'You don't speak Spanish, do you?' (in Spanish; the actor is Luis Tosar), and talks some gibberish about instruments that resonate after you stop playing them. They exchange a box of matches and the man leaves. The third and longest scene, which we are focusing on, involves a blonde woman (Tilda Swinton) who sits next to him (asking the customary question) and mentions a film, *Suspicion* (Alfred Hitchcock, 1941), which she especially enjoyed because it is like a dream that you are not sure you have had. She then explains a dream she did have about a room full of sand and a bird dipping a wing into it. She mentions another film, *The Lady from Shanghai* (Orson Welles, 1947): 'I like it in films when people just sit there, not saying anything.' Our unnamed hero just sits there, not saying anything, simply admiring the beautiful landscape. Well, he does do something: every time he gets a box of matches, he opens it, takes a piece of paper out of it, reads it, and eats it. **→John D Sanderson**

(Photos © Alicia G. González)

Directed by Jim Jarmusch
Scene description: At the square with an espresso in two separate cups
Timecode for scene: 0:31:44 – 0:37:38

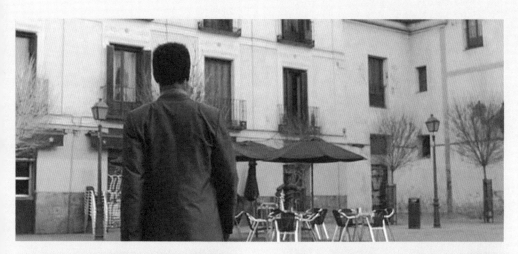

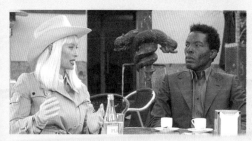

Images © 2009 Focus Features; Entertainment Farm (EF); PointBlank Films

BRIGHT YOUNG THINGS

Text by
RAFAEL
GÓMEZ
ALONSO

Neo-existentialism in Madrid cinema of the 1990s

DURING THE 1990S, a group of films set in the city of Madrid showed what it was like to be a young person by looking at the places where they meet and interact, showing their conflicts, frustrations and their lost illusions, often treated with some humour and irony, creating a style different from the vision of the cosmopolitan comedy of Madrid represented in previous decades, and showing a metropolitan anchorage for ensuing activities. In these scenes they try to solve all their expectations for a newer, happier future within a dystopian society and the rejection they feel at not yet being able to join a suitable social structure.

Among the directors who are part of this, and forming an axis of action with the cinematographic narrative of the city of Madrid, are Emilio Martínez Lázaro, Achero Mañas, Chus Gutiérrez and Álvaro

Fernández Armero: a generation of directors which achieved relative public success and won awards including Goyas (the Spanish Oscars) and a Gold Bear in Berlín (Martínez Lázaro for *Las palabras de Max/What Max Said* in 1978).

The film *Amo tu cama rica/I Love Your Rich Bed* directed by Martínez Lázaro in 1991 is one of the first works that explores the uneasy relationship and personal dissatisfaction with contemporary society. Different areas of the city become frames for the routines of distraction, particularly bars and nightclubs. The efforts to escape to daily routines mark the path of the characters trying to find new ways to gain personal contentment. In his next film, *Los peores años de nuestra vida/The Worst Years of Our Lives* (1994) the director explores the frustration of Alberto (Gabino Diego) in looking for a girlfriend. He is envious of his more attractive brother Roberto (Jorge Sanz), who promises to help him find a girl: Maria, who both fall for. Though apparently opposed, together they realize their pursued dreams. The film uses elements of metafiction with nods to Woody Allen's movies such as *The Purple Rose of Cairo* (1985) and *Manhattan* (1979). Many of the most iconic scenes of the film happen in the neighbourhood of Lavapiés, Madrid de Los Austrias. These street scenes of the city are the paths of meetings and misunderstandings: decisive areas in which to establish sudden encounters and possible future relationships.

The film *Historias del Kronen/Stories from the Kronen*, directed by Montxo Armendáriz

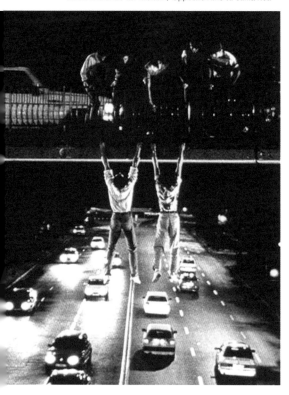

of personal insecurity.

In 1994, director Álvaro Fernández Armero made *Todo es mentira/It's All Lies*, starring among others, Coque Malla and Penélope Cruz, about the dissatisfactions of daily life, trouble with jobs and relationship conflicts. The male protagonist is unhappy in Madrid and continually talks about the city of Cuenca as an alternative, though, finally, he chooses to stay and lead his life in the city in a mood of alienation, hoping that things will one day change. *Nada en la nevera* of 1998, by the same director, is a comedy (again starring Coque Malla, with María Esteve) which demonstrates the problems of anxiety, lack of affection and insecurity between people. The city of Madrid is again the scene of alienation where the most unlikely and comical situations and unexpected, fortuitous meetings and the differing perceptions of the characters demonstrate the gap between what they think and the actions they perform.

Another, complementary, vision of the metropolis of Madrid comes from Chus Gutiérrez with his film *Insomnio/Sleepless in Madrid*, released in 1997, in which he describes psychological features of a group of young people marked by loneliness, self-deception and the fear of self-affirmation. One of them, played by the actress Candela Peña, wants to leave the city and spends her nights in the bus station, hoping to find something to replace her old relationship. This space is shown as an escape route but also serves as the scene of an encounter with an acquaintance, played by Ernesto Alterio. His psychological path is also marked by desperation that had led to an unfortunate marriage, so he, too, tries to flee the city. Casual relationships through urban daily routine create a web of attraction and expectations about the future.

Thus, the city appears as an uncomfortable environment for his protagonists, but none of them get to leave, generating a process of submission and learning new ways of relating. The breaking of or deviation from the social norms by the main characters indicates attitudes that make up a critical spirit of overcoming personal crisis and is a prototype of a neo-existentialism of postmodernity. �֍

in 1995, based on the novel by José Ángel Mañas, follows the activities a youth group that seeks new meaning in their lives. They meet daily at a bar named Kronen, where they explore the world of drugs, seeking to transgress ever further from conventional life, which generates a series of psychological and family conflicts. The offer of adventure in the streets of the city will turn into tragedy for one of them in a moment of taking one risk beyond the limit. The film can be seen as representing the desire for sensation that marks a representative group of middle class youth – what will eventually be called 'Generation X'. In a sense the movie formulates a flight based on the temptation of suicide. The spaces represent the apathy, boredom, frustration and crises

In Martínez Lázaro's *Amo tu cama rica* different areas of the city are scenes to frame the routines of the character's distractions, especially bars and nightclubs.

GO FURTHER

Recommended reading, useful websites and film availability

BOOKS

Directory of World Cinema: Spain
Edited by Lorenzo J Torres Hortelano,
(Intellect, 2011)

From Moscow to Madrid:
European Cities, Postmodern Cinema
By Ewa Mazierska and Laura Rascaroli
(London: I. B. Tauris, 2002)

The Pedro Almodóvar Archives
Pedro Almodóvar (Author), Vicente Molina-
Foix (Author), Gustavo Martín Garzo and
Paul Duncan (Editor)
(Taschen, 2010)

Madrid y el cine. Panorama
cinematográfico de cien años de historia
By Pascual Cebollada
and May G. Santa Eulalia
(Madrid: Comunidad de Madrid, Consejería
de Educación, 2000)

Madrid en el cine de la década de los
cincuenta
By Luis Deltell,
(Madrid: Ayuntamiento de Madrid, Área de
Gobierno de las Artes, 2006)

Primeros 25 Años de Cine en Madrid
1896-1920
By Josefina Martínez
(Madrid: Filmoteca Española, 1992)

De Madrid al cine. Una pantalla capital
Edited by Gonzalo Sanz Larrey
(Madrid: Centro Cultural de la Villa de
Madrid, 2009)

Así es Madrid en el cine
Edited by Eduardo Alaminos, Antonio
García Rayo and Javier Domingo
(Madrid: El Gran Caíd, Museo de Arte
Contemporáneo de Madrid, 2008)

ONLINE

EGEDA (Management of Audiovisual
Producers)
www.egeda.es

Madrid de cine (Spanish Film Screenings)
www.madriddecine.es
A unique business space for international
buyers, Spanish producers, sales companies
and international media to see the latest
releases of Spanish Cinema as well as
interviews with film directors, actors and
producers.

Madrid Film Comission
www.madridfilmcommission.com/MFC_
Inicio.asp

Semana de Cine Experimental de Madrid
www.semanacineexperimentalmadrid.com/10/
secciones/portada.php
The Experimental Film Week of Madrid
aims to promote cinematographic research
and serves as a platform for those engaged
in the experimental genre to show their
work annually.

FILM AVAILABILITY

The websites below provide DVDs of many
films reviewed in this book.

www.amazon.es
www.cinedeautor.com
www.criterion.com
www.dvdgo.com
www.elcorteingles.es
www.fnac.es

CONTRIBUTORS

Editor and contributing writer biographies

EDITOR

LORENZO J TORRES HORTELANO is a Senior Lecturer at Universidad Rey Juan Carlos (Audiovisual Language and Analysis and Film Theory). Books: *Directory of World Cinema: Spain* (ed., 2011), '*Primavera tardía*' *de Yasujiro Ozu: cine clásico y poética Zen* (2006), '*Poniente* (2002) *de Chus Gutierrez. En España no hay racismo*' *in Miradas sobre pasado y presente en el cine español* (1990-2005) (2008), '*La posibilidad del regreso a través de la experiencia estética*' *en Images d'exil. En el balcón vacío* (1962), *film de Jomí García Ascot* (2007). Regular contributor to the journal *Trama & Fondo* (*www. tramayfondo.com*) and others: '*Realism and Stylization. Man and Wilderness in Spanish Film of the 60's and 70's*", *Cine y... Revista de estudios interdisciplinarios sobre cine español* (2010); '*De lo vernacular y el World Cinema en Biutiful/About the vernacular and World Cinema in Biutiful*' *in Revista de Comunicación SEECI, 24, 2011* (*www.ucm.es/ info/seeci/Numeros/Numero%2024/InicioN24. html*). He moved to Madrid when he was 19 years old, and, from the moment he arrived, was fascinated by it (although he now lives 25 miles away).

CONTRIBUTORS

ANTONIO BARAYBAR FERNÁNDEZ was born in Chamberí, a castizo neighborhood of Madrid, and is Senior Lecturer of Audiovisual Communications and Advertising at Universidad Rey Juan Carlos. Books: *Marketing en Television* (*Marketing for Television*) (2006), articles and papers about movie industry and culture movements in Spain: '*La difícil relación del espectador español con su cine*' (2007), '*El débil impacto de la oferta cinematográfica española entre los jóvenes*' (2009), '*Del underground al mercado*' (2010).

JOSÉ LUIS CASTRO DE PAZ is Film historian and Audiovisual Communication Professor at Universidad de Santiago de Compostela. Books (sel.): *El surgimiento del telefilm* (1999), *Alfred Hitchcock* (2000), *Un cinema herido. Los turbios años cuarenta en el cine español* (1939-1950) (2002), *Cine y exilio. Forma(s) de la ausencia* (2004), *Fernando Fernán-Gómez* (2010) or *Del sainete al esperpento. Relecturas sobre cine español de los años 50* (wtih Josetxo Cerdán, 2011). In 2005 he directed, with Julio Pérez Perucha and Santos Zunzunegui, the collective volume *La nueva memoria. Historia(s) del cine español* (1939-2000). *Contributor to Directory of World Cinema: Spain* (2011).

JOSÉ RAMÓN GARITAONAINDÍA DE VERA has a PhD in Architecture and is Senior Lecturer at Escuela de Arquitectura at Universidad de A Coruña. Books: *Revitalización de núcleos rurales: Ribelles y su castillo* (1992), *Biblioteca en la Plaza de Santo Domingo. Pamplona* (1993), *Comunicación y fragmento. En busca de nuevos mitos. Arquitecturas de autor vol. 3* (1996), *Proyecto y vivienda. El diseño de los espacios para el hombre* (with Ignacio Araujo and Inmaculada Jiménez, 1996). Winner of numerous public tenders for the construction of buildings, his work has been the subject of monographic publications and has participated, for

example, in the collective exhibition at the Spanish Embassy in the United States of America between June and August 2004.

RAFAEL GÓMEZ ALONSO was born in Madrid and is Senior Lecturer of Visual Culture and Film & Perfoming Arts and Head of Department of Audiovisual Communication at Universidad Rey Juan Carlos. Publications: *Cultura Audiovisual. Itinerarios y rupturas* (2008). Contributor to *Directory of World Cinema: Spain* (2011). He is an expert in the cinema and culture of *La Movida*.

STEVEN MARSH teaches Spanish Film and Cultural Studies at the University of Illinois, Chicago. Publications: *Popular Spanish Film Under Franco: Comedy and the Weakening of the State* (2006) and co-editor of *Gender and Spanish Film* (2004). He is currently writing a counter-history of Spanish sound cinema. Contributor to *Directory of World Cinema: Spain* (2011). He shares his time between Chicago and Madrid.

AGUSTÍN RUBIO ALCOVER is a Lecturer in Film History, Production and Editing at the Universidad Jaime I de Castellón, where he belongs to the research group ITACA-UJI. Regular contributor to journals, he has also published *El don de la imagen. Un concepto del cine contemporáneo* (2010). Contributor to *Directory of World Cinema: Spain* (2011). *AEHC Congress Book 'Aurora y melancolía. El cine de la II República española'* (ed. with Julio Pérez Perucha), and contributor to *Análisis del*

cine contemporáneo: estrategias estéticas, narrativas y de puesta en escena (2011).

JOHN D SANDERSON is a Senior Lecturer on Film and Literature and on Film and Theatre Translation at the Universidad de Alicante, Spain. He teaches on post-graduate courses at the Universities of Málaga, Valencia and Centro de Estudios Ciudad de la Luz (Alicante). Publications: *¿Cine de autor?: revisión del concepto de autoría cinematográfica* (2005), *Trazos de cine español* (2007), and *Constructores de ilusiones: la dirección artística en España* (2010) with Jorge Gorostiza. Contributor to *Directory of World Cinema: Spain* (2011).

HELIO SAN MIGUEL was born in Madrid and holds a PhD in Philosophy and an MFA in Film and TV Production from New York University's Tisch School of the Arts. He is one of the contributors to *The Cinema of Latin America*, published by Wallflower Press, and *Tierra en Trance*, published by Alianza Editorial, and has written numerous film articles. He is also the writer and director of *Blindness*, a 32-minute fiction film that has been selected in over thirty film festivals including the prestigious New York's New Filmmakers and the European Film Festival. He teaches film and philosophy at The New School in New York and spends much of his free time in Madrid.

ALICIA IGREY G. MAICAS has a Degree in Audio-visual Communication and a Professional Music Certificate in →

CONTRIBUTORS

Editor and contributing writer biographies (continued)

Violin. She also has a degree on 'Film Direction' and 'Sound and Music for Films' by Milodón Cinema. She has worked as Production Assistant of Elisa Eliash's *Aqui estoy/Aquí no* (2010). She combines her passion for music and cinema working as a violin teacher and producer in several projects. Currently she is working for a Masters Degree in Spanish Cinema Studies. She is one of the creators of the Film School and Production Company *Malapata Producciones (malapata.zobyhost.com)*

EDUARDO HERNÁNDEZ LÓPEZ has a Degree in Audio-visual Communication and is Vice-President of Photography Association 'A Través del Objetivo' (*www.flickr.com/photos/edihernandez*). He writes about movies on the *Crazyminds'* Website (*www.crazyminds.es/cine/*), and is starting his career as screenwriter and director. Currently, he is working for a Masters Degree in 16mm cinema at Metropolis film school of Madrid.

MIRIAM MONTERO ANTONA has a Degree in Audio-visual Communication and is President of the Photography Association 'A Través del Objetivo' (*www.flickr.com/photos/miriammontero/*). She is the coordinator of the 'Film Section' of Crazyminds' Web (*www.crazyminds.es/cine/*), and she is starting her career as screenwriter and actress. Currently, she is preparing the 3rd 'Week of Photography' at Universidad Rey Juan Carlos.

LARA PÉREZ DE VILLAR BAYÓN has a Degree in Audio-visual Communication and is working very hard to be able to continue her studies of video editing. She is an amateur photographer. Her photos can be seen at *www.flickr.com/photos/laritaitaita/*

FILMOGRAPHY

All films mentioned or featured in this book

FILMOGRAPHY

All films mentioned or featured in this book (continued)

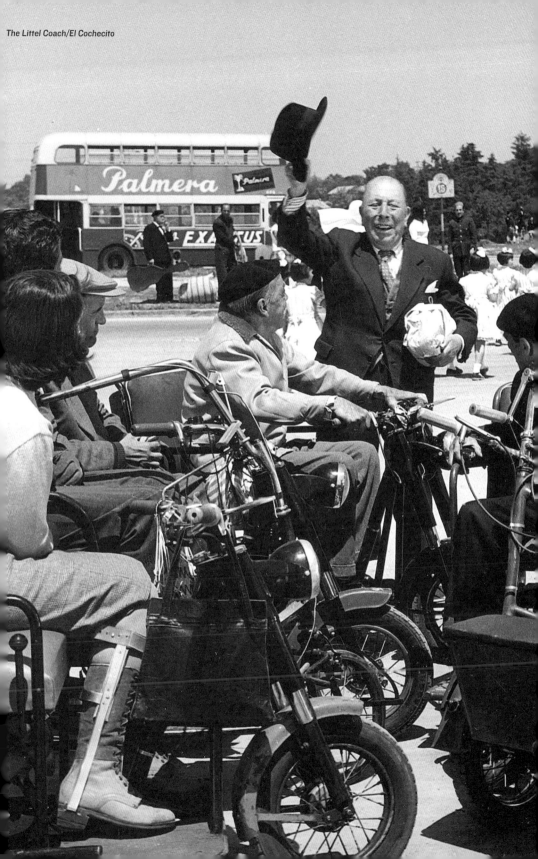

WORLD FILM LOCATIONS EXPLORING THE CITY ONSCREEN

www.intellectbooks.com